# The
# *Complete*
# *Sketching Book*

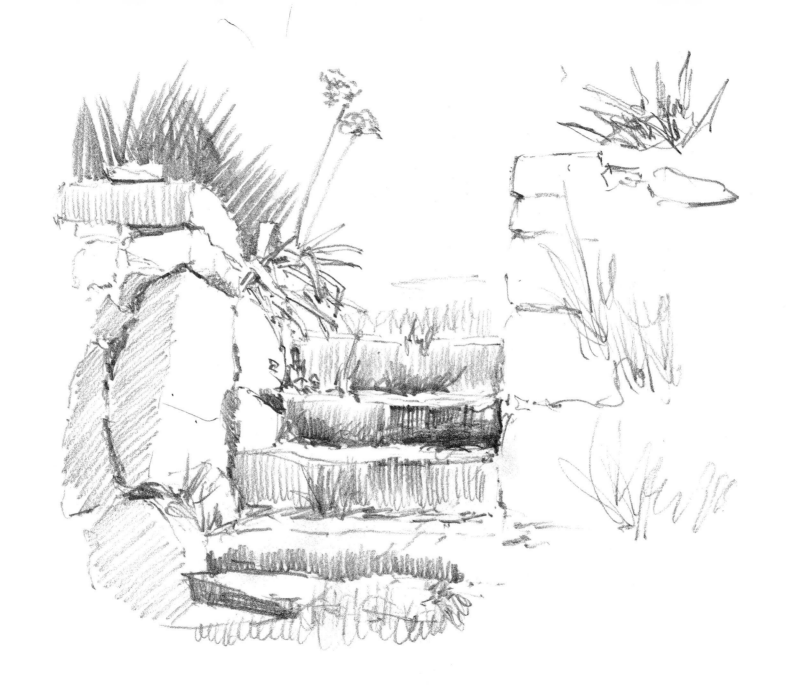

# The
# Complete
# Sketching Book

## John Hamilton

STUDIO
VISTA

Studio Vista
an imprint of
Cassell
Wellington House, 125 Strand
London WC2R 0BB

First published in this paperback edition 1998
Reprinted 1998, 1999

British Library Cataloguing in Publication Data
A catalogue record for this book is available from the British Library

ISBN 0-289-80173-7

Much of the material in this book has been previously published
in John Hamilton's *Sketching with a Pencil* (1989)
and *Sketching at Home* (1991)

Printed in Great Britain by Hillman Printers (Frome) Limited

# Contents

# Introduction

These days many people either have more time to do other things like drawing, or when they do have a break from a stressful life they want to turn their hand to sketching as a complete relaxation. Hardly a day goes by without some visitor to my studio saying 'I do wish I could draw, you know I did try once but I was no good at it.' This is sad because I don't think it is true. What they are saying is that they started off by attempting something that was too difficult, failed in the attempt and gave up hope.

I am convinced that this happens. We buy some equipment when on holiday, see a glorious view and decide to draw or to paint it. Disaster follows and the only thing that remains is loss of confidence and a feeling of frustration. If you have had such an experience, this book is to help you start again.

I want to dispel two myths. First, no matter what you have heard or read, you do not need a lot of equipment. You are sketching with a pencil, so you will need a pad, pencils and a rubber: that's all. Second, sketching is not for holidays only. Sketching is for any time—the odd half hour in the day, or an alternative to television in the evening. The more enthusiastic you become the easier it will be to find the time, and the more time you can spend sketching, the better your results will be.

Please take the time to read the whole of this short introduction. It could well mean the difference between success and disappointment. Accept the fact that you are just beginning, and just as with anything you do in life you have to develop your skills by stages. You learn to drive or you learn to cook, and now you can learn to draw. You didn't make a soufflé as the first dish you cooked and you didn't drive in the fast lane of a motorway after your first driving lesson—so don't expect to produce a masterpiece at the first attempt at sketching.

One of the drawbacks of a book of this kind is that the author has produced sketches which you will find difficult to achieve at first. This is inevitable. I believe (and others will disagree forcefully) that while it is always better to draw from an object, there is nothing wrong with copying a photograph or someone else's work, providing you don't confine yourself to copying.

At this stage drawing is all about confidence and I believe that anything that helps you to find confidence is permissable. I've heard people say that you should avoid using a rubber (or, for this one time only, if you prefer it, eraser)—but why ever not? I use a rubber whenever I want to alter a line. Of course you can use a rubber—though I suggest it should be soft and bungy with a sharp edge and large enough not to get lost.

Anyway, I have just one more plea. It is surprising how many really simple things there are all round you. So do please select something simple to start with. If you want to draw out of doors as a start then turn to page 69, but I hope you will find a simple subject inside the house and have fun with it. When you start looking, you will begin to see all sorts of possible subjects. As you read on you will notice that I don't suggest complete drawings every time. You can just do the edge or one side of an object and leave the rest to your imagination. It may well be that the whole object is somewhat beyond you at this stage, but you can perfectly well convey meaning, shape and substance with your sketch. It will also help you focus in on the essentials of the object you are sketching; you will find yourself looking at familiar, everyday items and seeing them—really seeing them—for the first time.

In time I know that you will gain the confidence that will assure you of many hours of real enjoyment—so let's make a start.

*John Hamilton*

As I said on the previous page, so many people seem to give up drawing almost before they have begun. This is usually because they choose a subject which is too difficult, and not surprisingly they are disheartened by the result. **We** are not going to fall into that trap.

Having said that, let's begin.

Firstly, what equipment should you have?

For your SKETCH BOOK, choose one with a strong cardboard back and some form of spiral binding. A glued binding tends to fall apart with use, and particularly so if it gets wet. As for size, I use an A4 (the same size as this book), but with experience you will find the size that suits you. Stick to that size. A smooth white paper can be found at your art shop, and it will be adequate for your early work. Always include a large BULLDOG clip to stop the paper blowing in the wind, and include a clear plastic 12 inch RULER.

Your PENCILS should be good quality, and I suggest HB, 2B, 4B and 6B. Pencils are graded from 6H which is very hard and is used mostly by draughtsmen, through to 6B which is soft and very black. HB is in the middle. You can always add to your collection at any time, but I want to start you off with the minimum of equipment so as not to confuse you.

You must include a very sharp KNIFE. A Stanley type is ideal, and a pencil sharpener can be included, although it does not give you a long enough point for everything you will want to do. Put a strip of fine sandpaper in your bag. It will be invaluable for sharpening up the point of your pencils.

Include a good RUBBER. The best kind will be very soft and bungy, and large enough not to become lost.

Finally we come to the all-important question of a comfortable STOOL. There are all kinds and sizes on the market, but I went to a fishing tackle shop and found an ideal model. It is light, and has a strap which enables you to carry it from the shoulder and thus have both hands free. However the best thing about it is that it has a waterproof bag attached to the side of the stool, and it carries all my equipment.

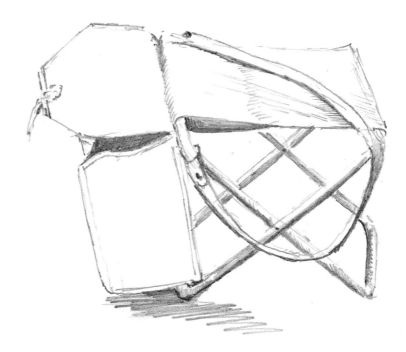

Before you start drawing, I am going to suggest that you use the last page of your sketch book or any spare sheet of paper to try out your pencils and discover the difference between HB and 6B. Look at the shading I have done opposite and do the same. Relax your wrist, practise starting with quite firm pressure and then gradually slacken off. You will find the secret is a supple wrist.

Try laying your ruler on the page and shading up to it.

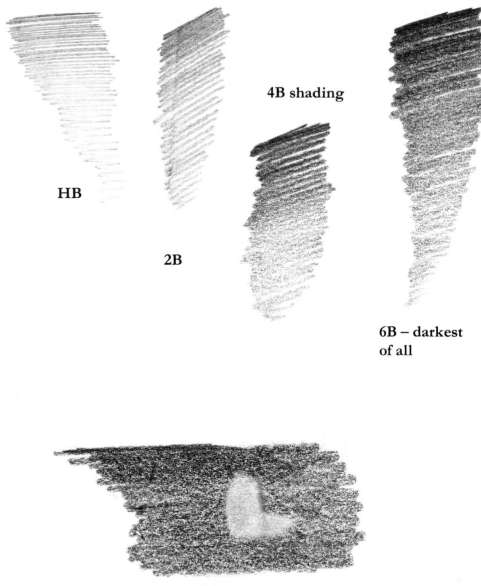

**4B shading**

**HB**

**2B**

**6B – darkest of all**

**6B**

**4B**

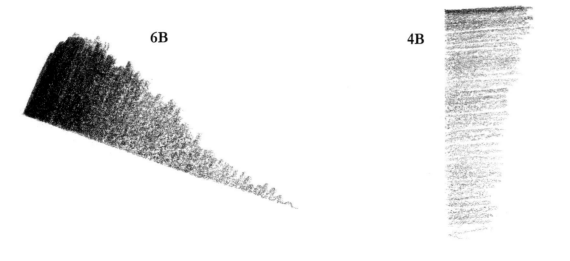

Finally use your rubber, but beware! Clean the rubber on a spare piece of paper after each use. In this way it won't make smudges on your work.

Have fun, and keep practising. The golden rule is a light touch and a supple wrist. See how dark you can make your shading, then release the pressure gradually to let it become lighter and lighter until it is hardly visible.

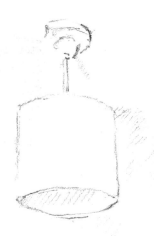

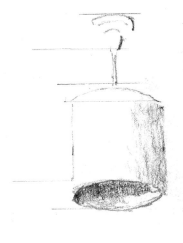

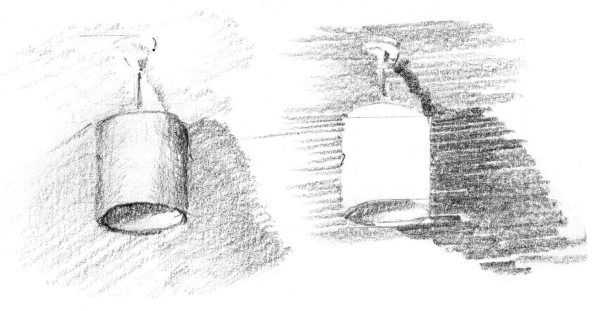

**4B**    **2B**

## Sketching at Home

The advantage of sketching in the home is that everything you want is at hand. Even if you have only thirty minutes to spare there is something you can do.

I don't want to impose anything on you, but remember that you are only just beginning. It is frustrating to choose a subject which is beyond you and make a mess of it. 'Oh I can't draw,' you'll say, but it isn't true. The problem is that you crossed over into the fast lane after the first driving lesson.

Why not try something simple, like a lamp shade or perhaps a part of a wooden chair? Not the whole chair, just a corner of the back of the chair. I have done the same lamp shade with different shading. Start by sketching in the lamp very lightly, so corrections are easy, and don't be afraid to use your rubber.

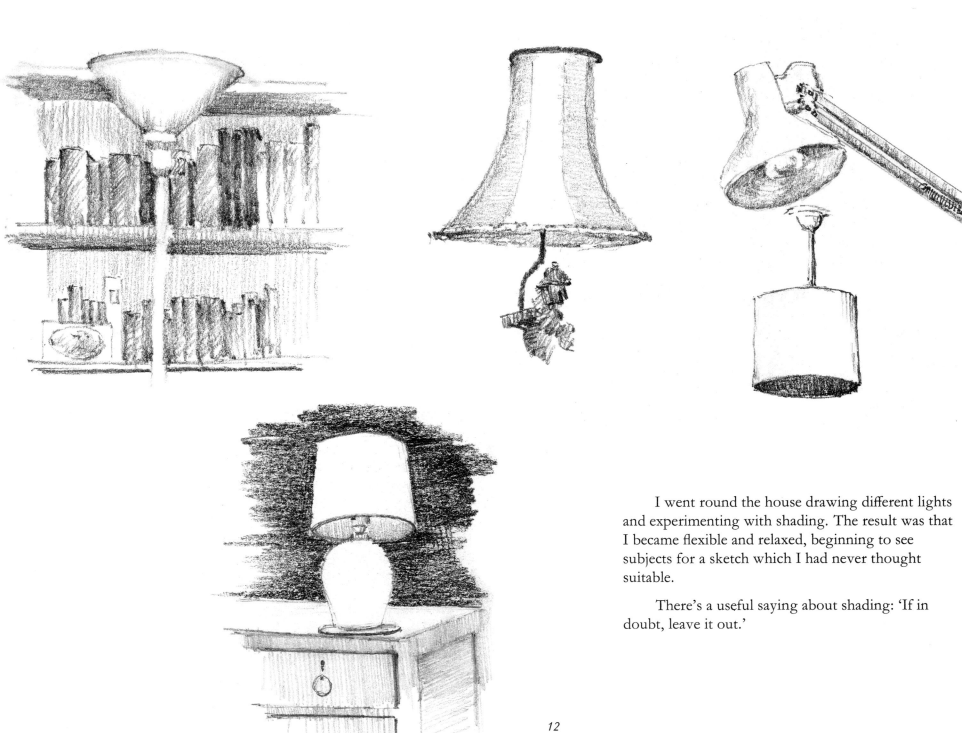

I went round the house drawing different lights and experimenting with shading. The result was that I became flexible and relaxed, beginning to see subjects for a sketch which I had never thought suitable.

There's a useful saying about shading: 'If in doubt, leave it out.'

Here is a little exercise with still life. Place the objects on a table and shine a light from one side. Don't move them, but walk round the table to find the most attractive composition. Decide how dark you want your finished work to be. My cube became a box and was more attractive with a lighter shade. In this exercise I used 2B and 4B pencils.

When you start a sketch like this use the lightest of touch to draw in the outlines. I used a 2B pencil with a **very** sharp point. My large soft rubber with a straight edge was invaluable. This kind of drawing is not always easy, and if it doesn't appeal to you—don't push it, but stick to subjects in which you feel confident.

Remember—keep your pencils sharp. I had a strip of sandpaper by me and after making a long point with my knife, I used the sandpaper to keep the point sharp.

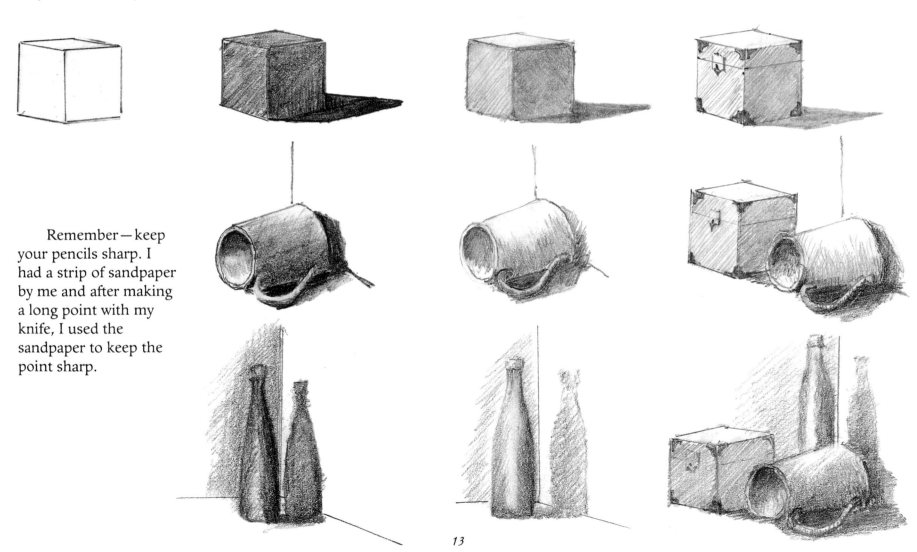

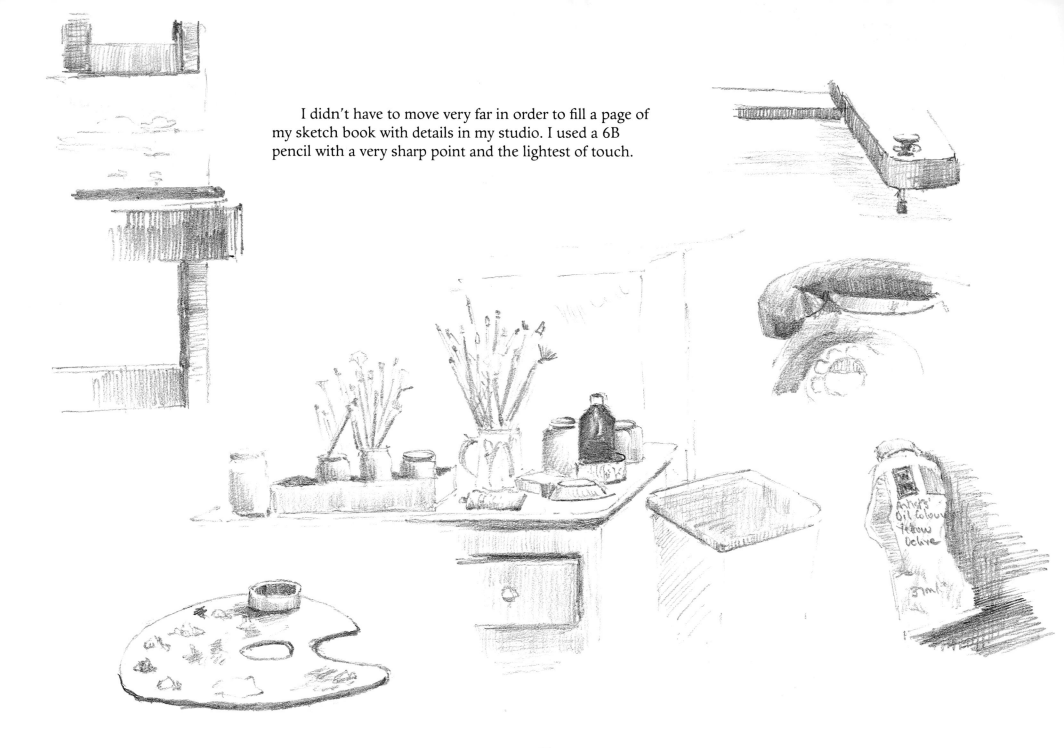

I didn't have to move very far in order to fill a page of my sketch book with details in my studio. I used a 6B pencil with a very sharp point and the lightest of touch.

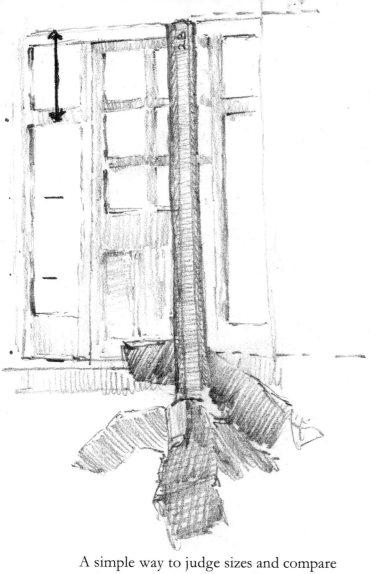

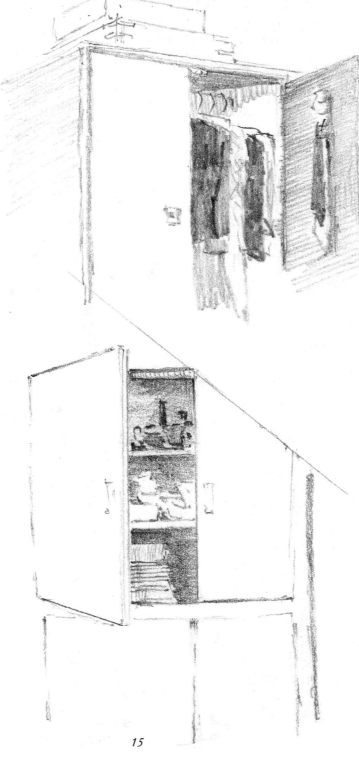

Doors of all kinds are interesting and useful subjects for a drawing. (They are also good for practising perspective. Read on!)

A simple way to judge sizes and compare proportions is to hold your pencil upright at arm's length between your face and the object to be measured, close one eye and look at the object as compared to the length of your pencil. The relative proportion of other objects can be gauged in the same way. For instance, the top left-hand window pane is one quarter of the total height of the door in my sketch.

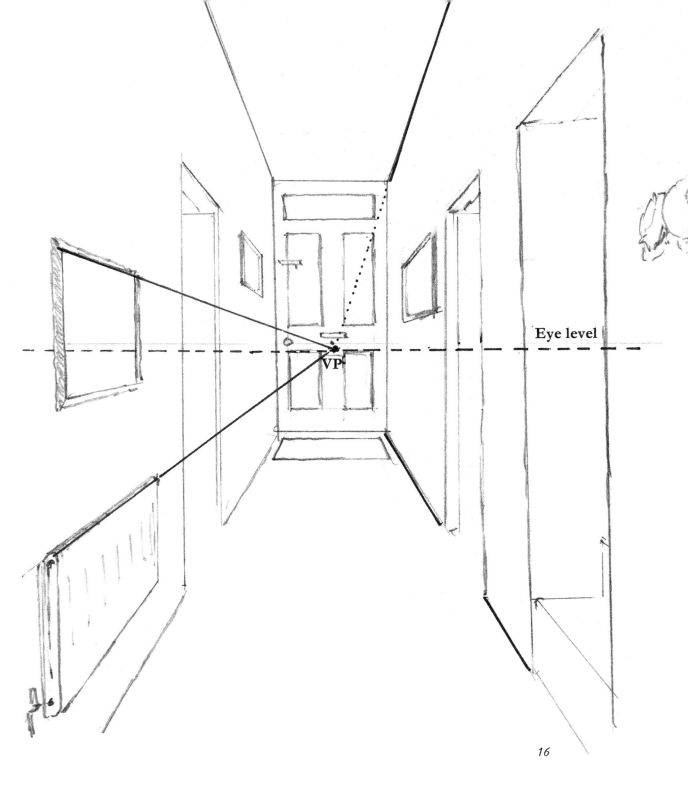

**Eye level**

VP

I was sitting on a low stool facing down the passage to the front door. Looking straight ahead my eye was level with a line just below the door handle: my eye level. The non-vertical straight lines in the picture, such as the top of the picture frame, the radiator and also the skirting boards, when projected all come to the same point on the eye level. This is called the **vanishing point** (VP) and we are discussing **perspective**.

Test this out for yourself in a room. Sit on a chair and hold a ruler at arm's length, and close one eye. Now lay it in line with the top of one of your pictures or a window frame, and then with the bottom of the same object. You will see that these two lines, when projected, converge to the same point — the VP — and that this point is at eye level. Now stand up and do the same exercise. You will see that the lines all converge somewhere along the new eye level.

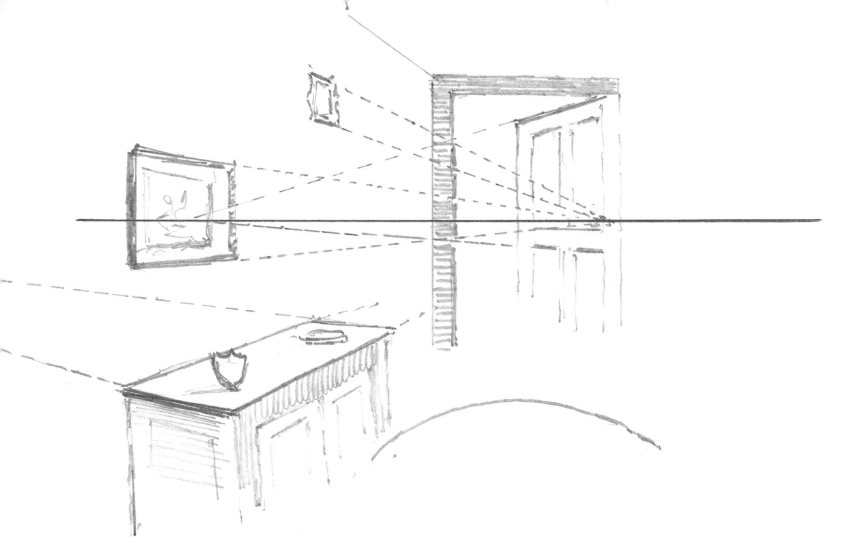

I sat at a table looking towards the door into the kitchen, and drew some of the objects around me. The dark horizontal line shows my eye level. The pictures on the wall to the left all lead my eye to a VP straight ahead. The partly open door led off to a VP to the left, but again somewhere on the eye level. The top of the cabinet led off to a VP a long way to the left, but again at eye level.

Try to do this yourself. Sit not exactly in the centre of a room, facing a wall. Look straight ahead and make a mental note of the line of your eye level. Very faintly draw in this line and make a sketch of the scene before you, being sure to include pictures and perhaps a window on the left or right. Now stop drawing and by laying your ruler along the top and bottom of any pictures or windows you have drawn, see if the lines converge to a VP. Don't be disheartened if they don't; in time perspective will become second nature.

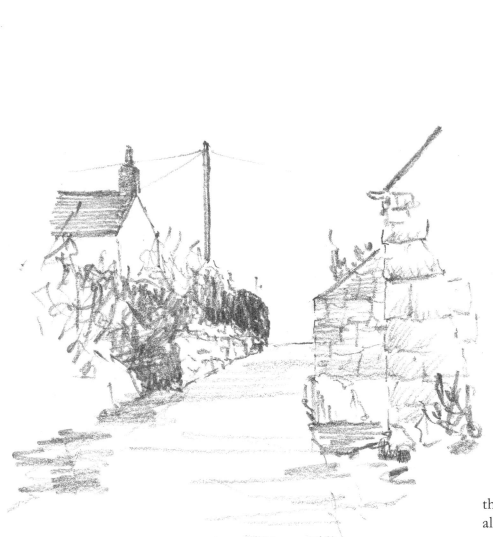

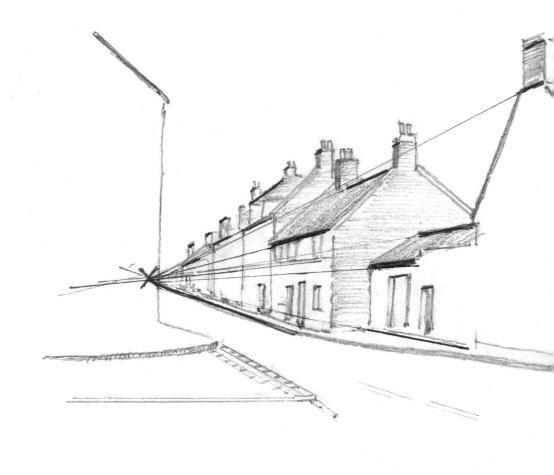

The same principle applies everywhere. Looking up the street we see that the lines of the roofs and the roadside all come together at a VP. This should always be in your mind when you are sketching outside.

It may be worth spending time looking at illustrations or photographs of buildings and laying a ruler along all the lines that are not vertical, and see where they meet. Try this sometime. It is probably the best way to fix perspective in your mind. Once you have mastered the principle, you will never be intimidated again by the word perspective.

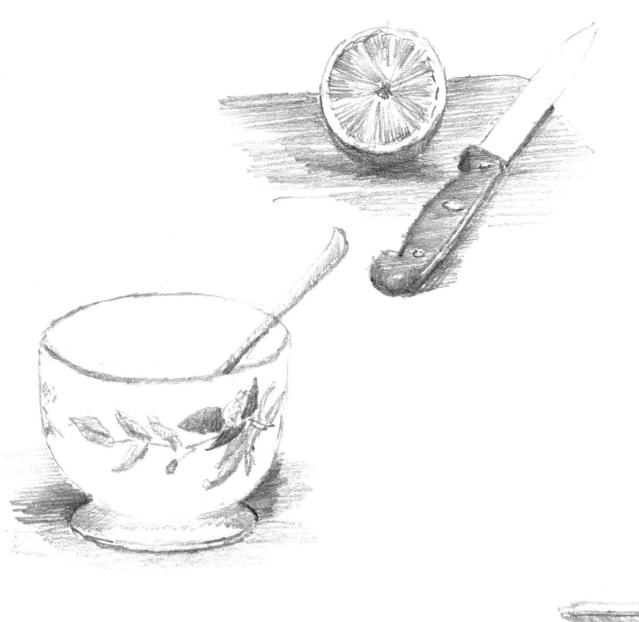

I don't want to spend too much time on perspective, important though it is, and we will return to it later. By now I hope you will have found that there is a wealth of possible subjects for a sketch in the house. Keep to the principle of using a really light touch to start with and when you are satisfied with the main structure, bring it all to life with shading. The spoons are a case in point. I used a 2B pencil for a faint outline, but now we have a feeling that they are standing out from the wall.

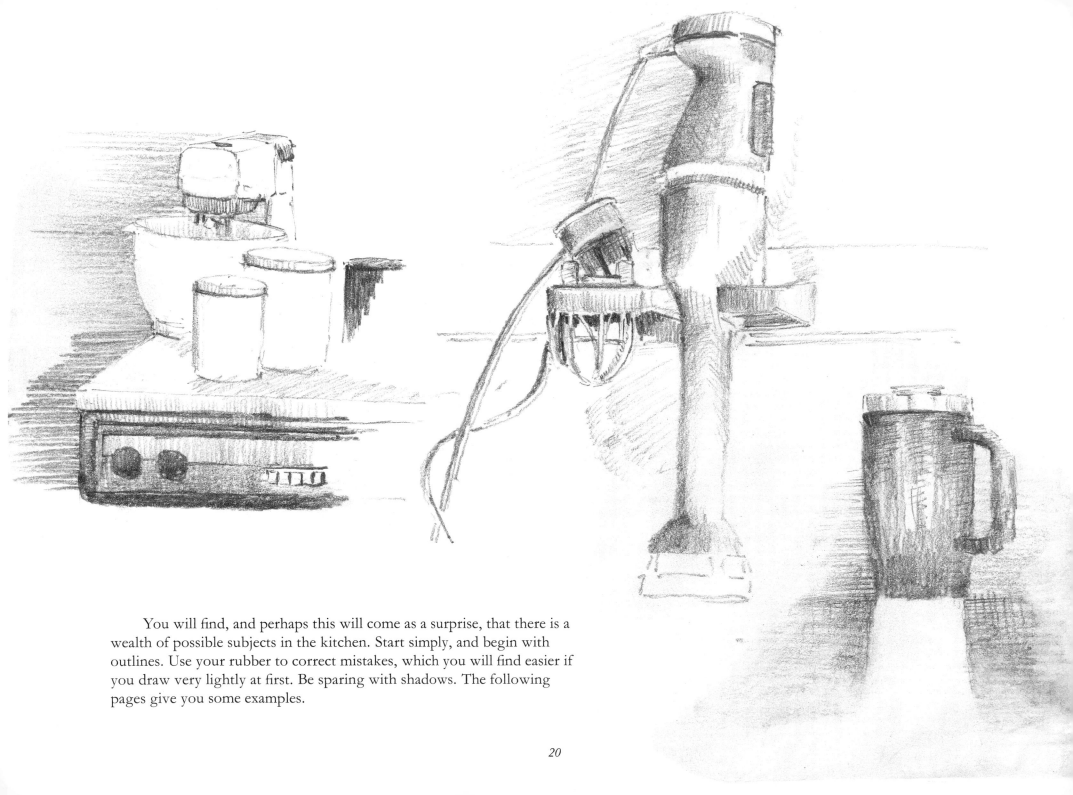

You will find, and perhaps this will come as a surprise, that there is a wealth of possible subjects in the kitchen. Start simply, and begin with outlines. Use your rubber to correct mistakes, which you will find easier if you draw very lightly at first. Be sparing with shadows. The following pages give you some examples.

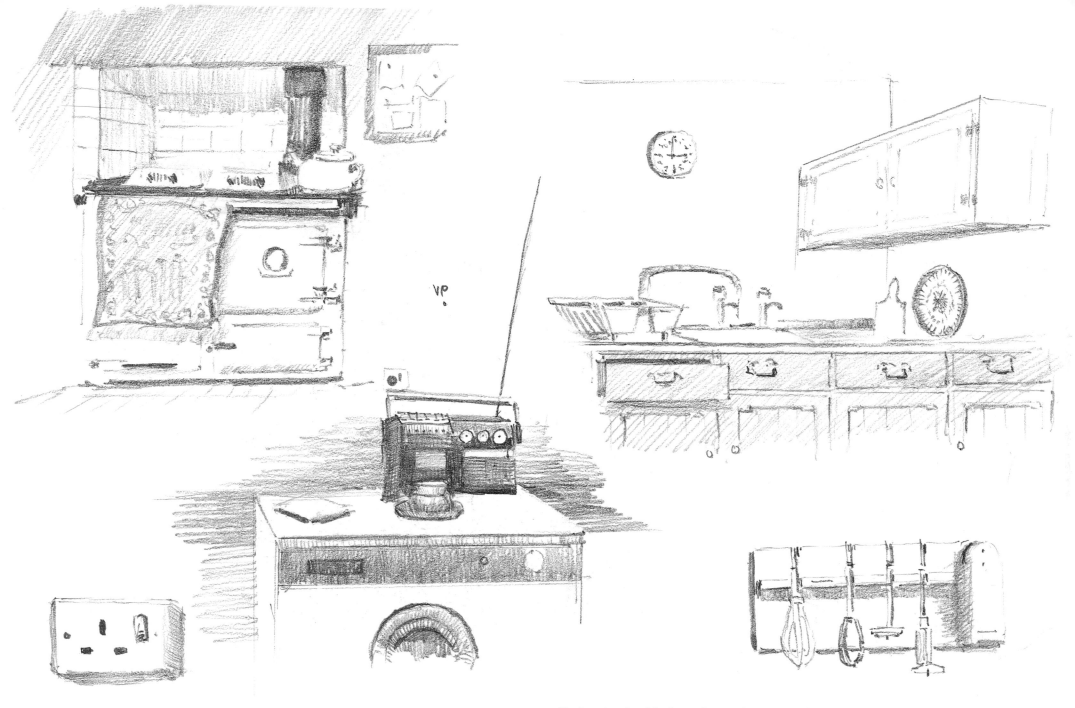

Sitting in the kitchen for an hour produced these little sketches.

From where you happen to be sitting you will find all kinds of objects that are interesting to draw. Just sketch away with a light touch using an HB or 2B pencil. Contrary to what many people think, I never have any hesitation in using my rubber, but avoid taking out heavy shading or you will smudge your work. — So, start off lightly and satisfy yourself that your outline is correct before doing any heavy shading. If you must remove some dark pencil work, for instance, when putting in highlights, clean your rubber after each stroke.

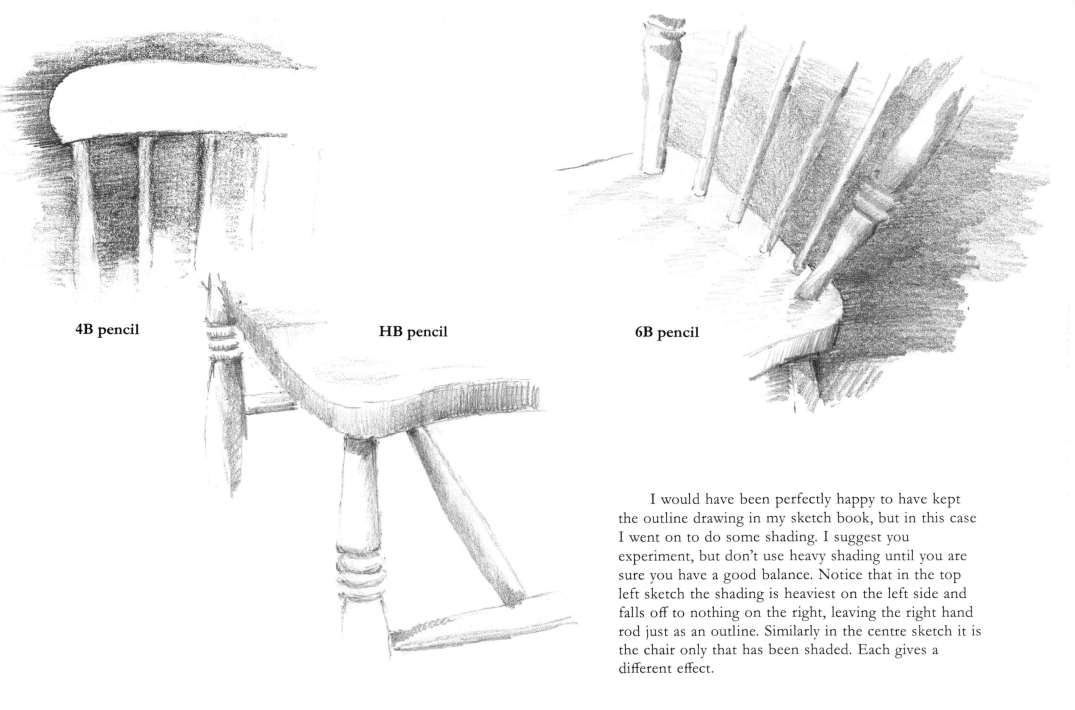

**4B pencil**

**HB pencil**

**6B pencil**

I would have been perfectly happy to have kept the outline drawing in my sketch book, but in this case I went on to do some shading. I suggest you experiment, but don't use heavy shading until you are sure you have a good balance. Notice that in the top left sketch the shading is heaviest on the left side and falls off to nothing on the right, leaving the right hand rod just as an outline. Similarly in the centre sketch it is the chair only that has been shaded. Each gives a different effect.

Still-life still has to live! Whether it is a collection of bottles or a bowl of fruit, it is either alive or it is flat. So how do we go about tackling a bowl of assorted fruits?

I suggest that you spend a moment or two composing the fruit, and noticing how the light falls on the surfaces. Try not to complicate the subject, which is already quite challenging.

Personally, I spend quite a long time endeavouring to draw the outline accurately and to scale. This I do with a very light touch, using an HB or a 2B pencil, and my rubber.

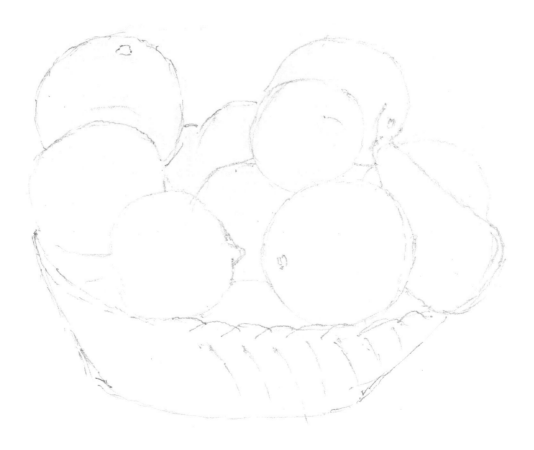

Have you ever thought of looking at what you have done through a mirror? It is an excellent way to check on your ability in handling shapes and symmetry. Why not find a hand mirror now and look at what you have done. It is surprising how errors show up if you reverse the image.

Here is the second stage in my still-life drawing. I have begun to put in the deeper shadows, but have not concentrated on any one piece of fruit. I am endeavouring to keep a balance. The bowl is formed of elaborate and highly coloured tracery, but you will see that I don't want it to dominate.

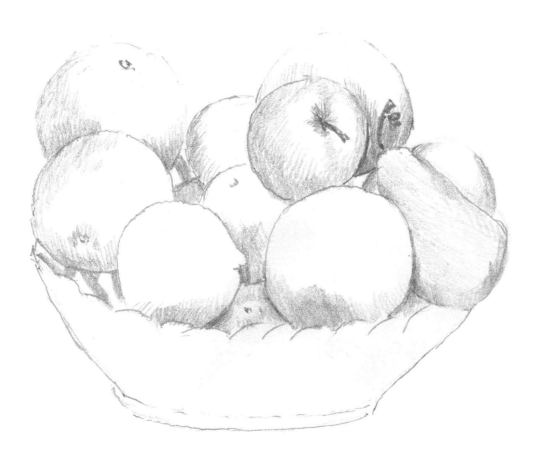

This is the last stage. It is always a problem to know when to stop, and if there is any advice I can give, it would be to stop too early rather than too late. There is a temptation to fiddle with a pencil and this can often spoil your picture. Here, the bowl is almost as detailed as the fruit. Any more detail on the bowl would bring the eye down from the fruit to concentrate on the bowl — and the subject of the sketch would be lost.

I think I might agree with you if you said I had gone too far already.

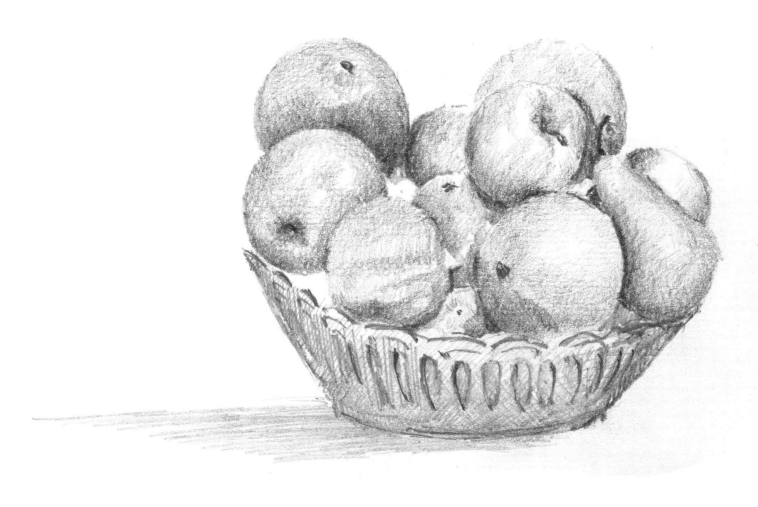

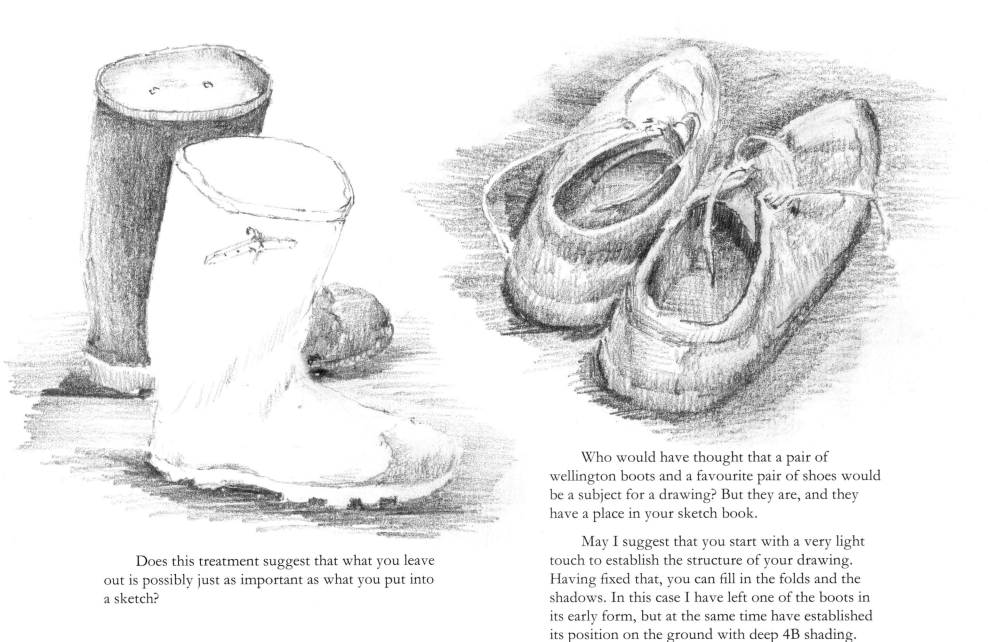

Does this treatment suggest that what you leave out is possibly just as important as what you put into a sketch?

Who would have thought that a pair of wellington boots and a favourite pair of shoes would be a subject for a drawing? But they are, and they have a place in your sketch book.

May I suggest that you start with a very light touch to establish the structure of your drawing. Having fixed that, you can fill in the folds and the shadows. In this case I have left one of the boots in its early form, but at the same time have established its position on the ground with deep 4B shading.

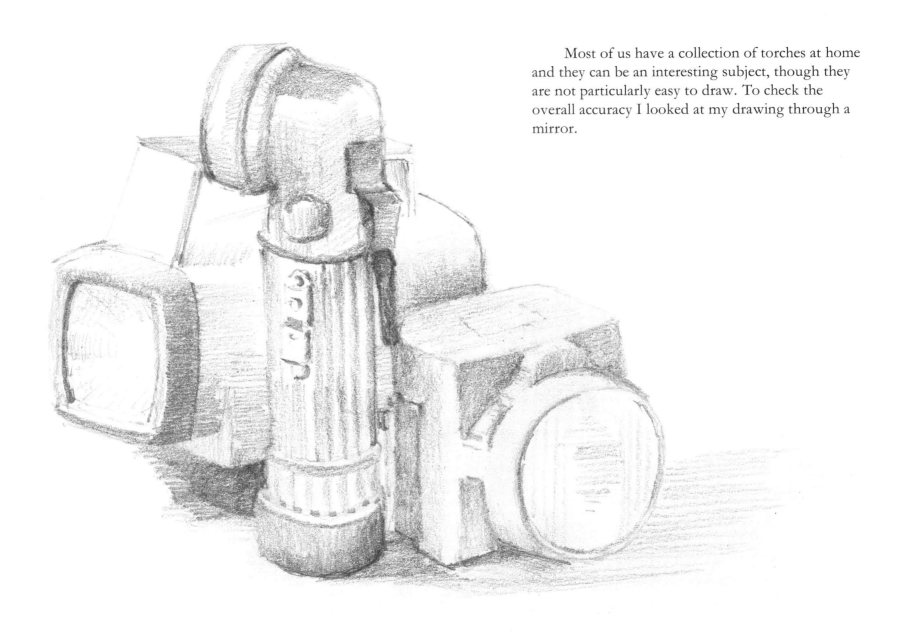

Most of us have a collection of torches at home and they can be an interesting subject, though they are not particularly easy to draw. To check the overall accuracy I looked at my drawing through a mirror.

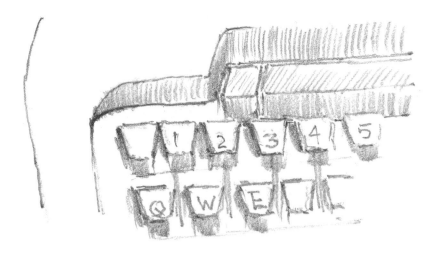

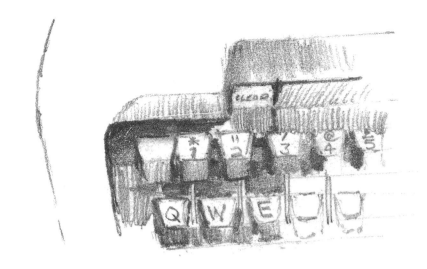

Here is a suggestion for a part of the keyboard of a typewriter. First an outline drawing and a little shading.

Now we've got it just about right. Note what I have left out.

Now we've spoiled it by doing too much!

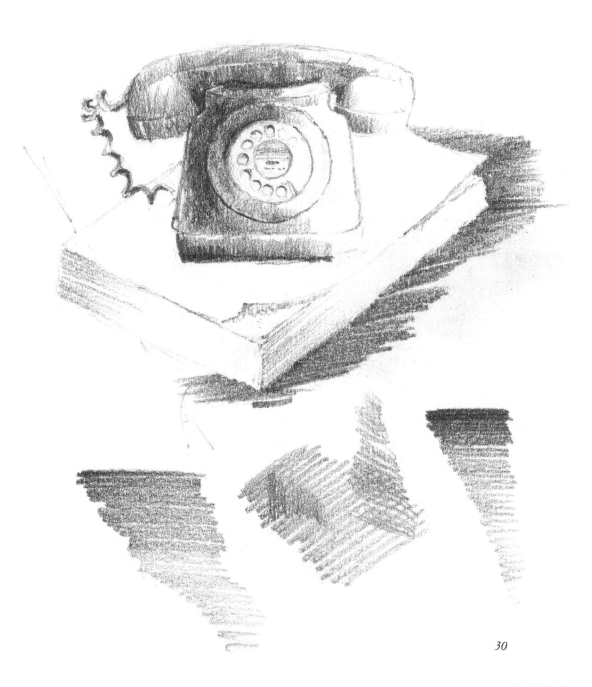

Notice how this sketch has been built up.

I started with very faint outlines which established the structure of the instrument and the telephone directory beneath it (but I had to make good use of my rubber before I got it right!). All this was with a 2B pencil. Shading began with the darkest shadows with a 4B, but I have left one side unshaded to show you how it developed. Think about the effectiveness of the heavy shading (and the direction of the lines of the pencil) against the outline of the book.

Finally, don't forget to practise your shading exercises. They will help you to achieve a supple wrist and lightness of touch.

If you want to try your hand at a table lamp illuminating a room, remember that the area surrounding the light must be darker than the light source. In the sketches on this and the following page I have chosen the light as the focal point of the drawing with the shadows giving strength to the surrounding area. Once again it is important to stress that a light touch at the start with an HB pencil will help you to design the layout.

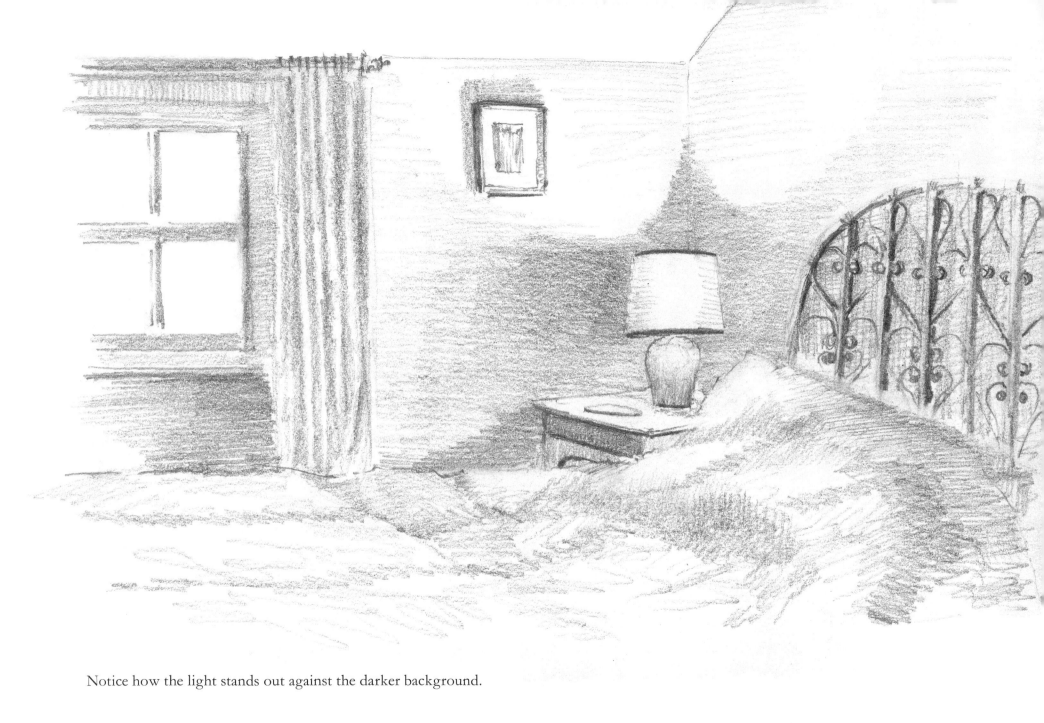

Notice how the light stands out against the darker background.

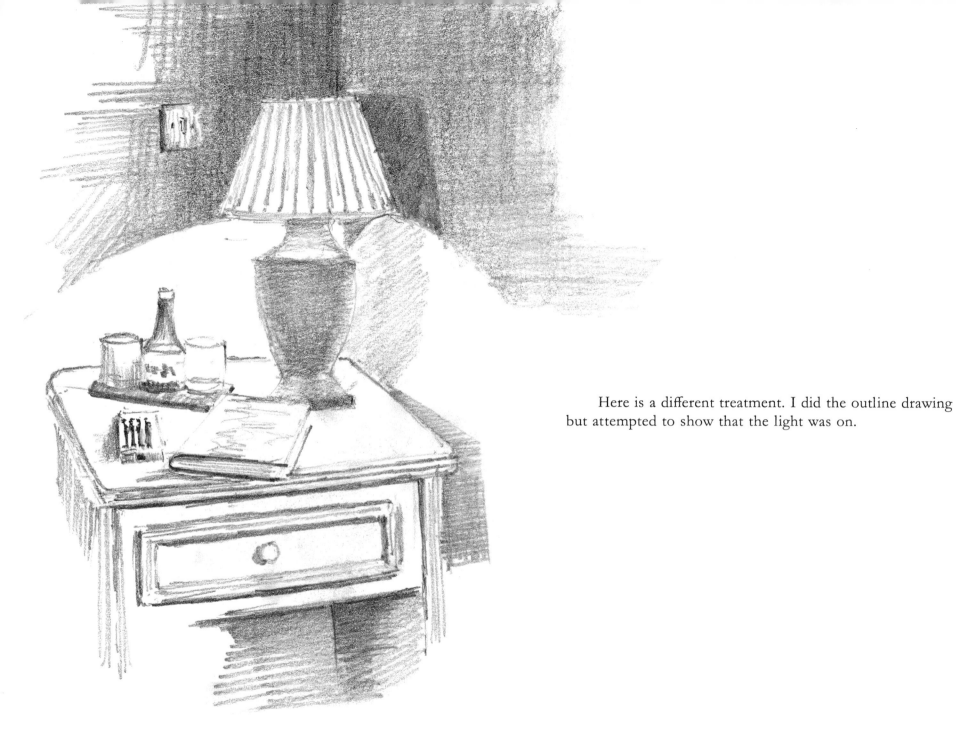

Here is a different treatment. I did the outline drawing but attempted to show that the light was on.

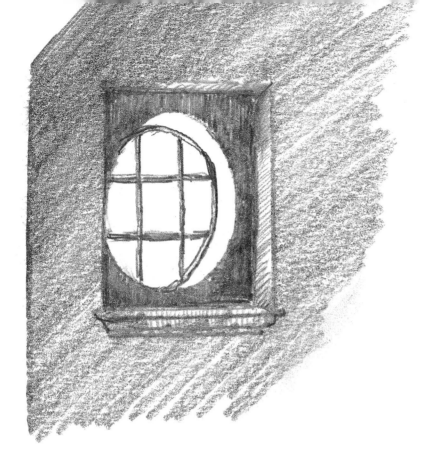

There was an attractive round window in the wall of a friend's sitting room. I sketched it lightly and then shaded it but I liked the composition of the whole corner of that room so did another sketch including the lamp, table and chair—all in outline.

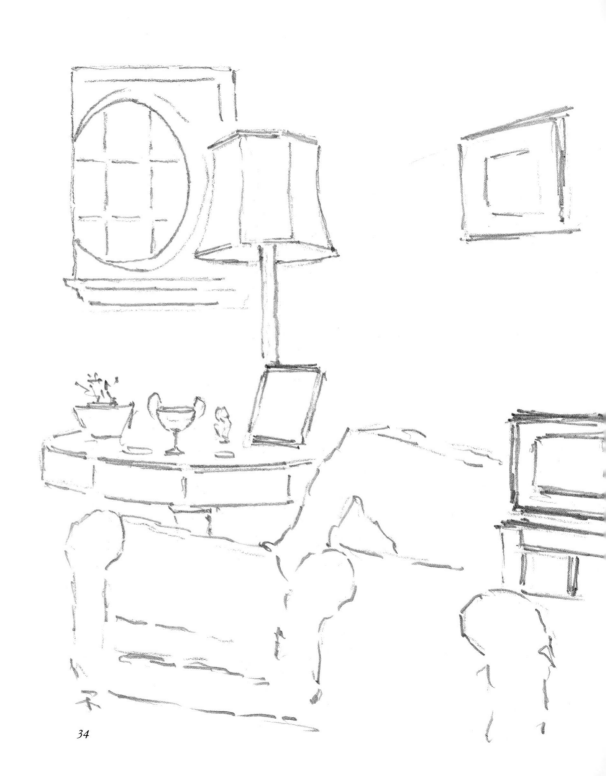

As the sketch developed I did exactly the reverse. I left the window almost totally unshaded and made the round table the central part of the drawing. It was a light and airy room with lots of windows; I tried to convey that by leaving the back of the arm chair unshaded and strengthening the shadow from the lamp.

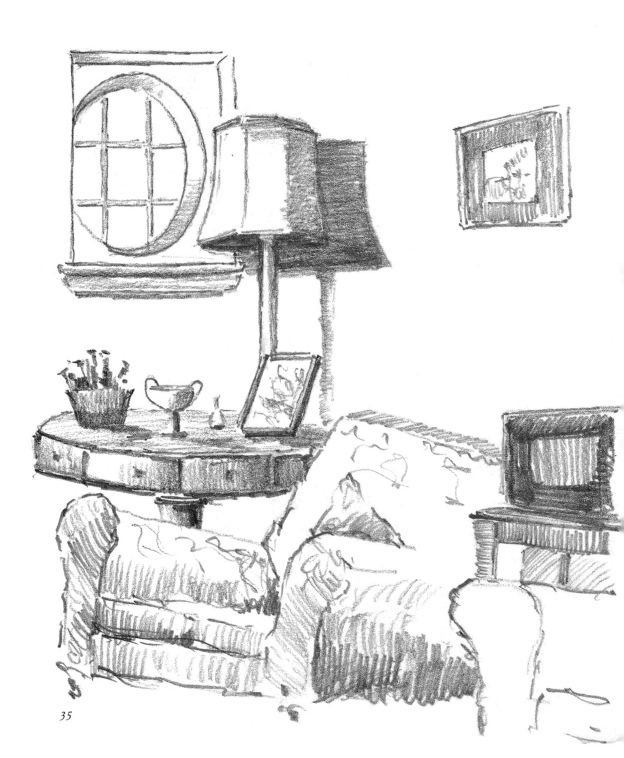

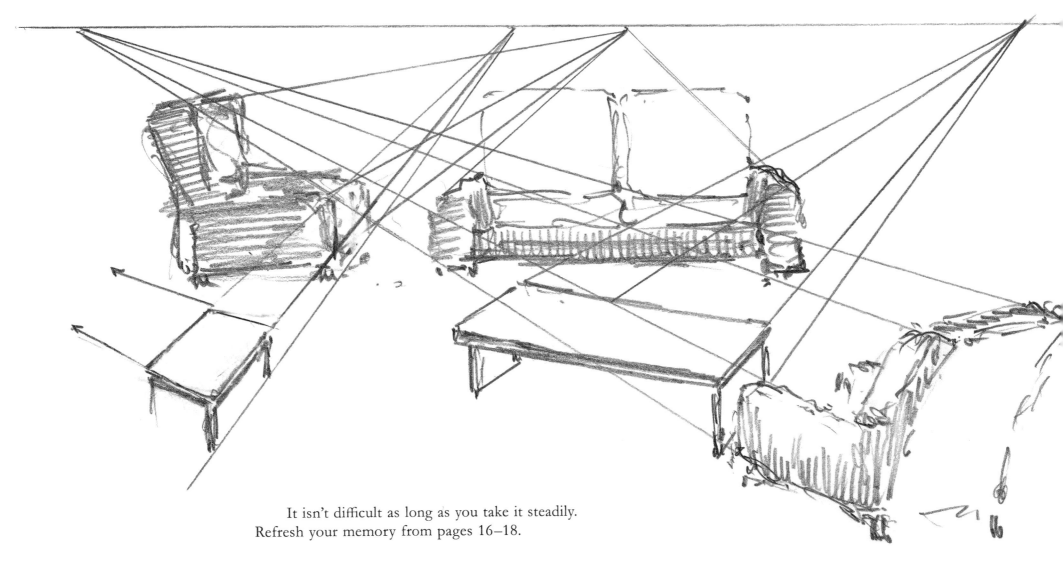

It isn't difficult as long as you take it steadily.
Refresh your memory from pages 16–18.

Look at these two pages. The cubes represent some of the furniture on the opposite page which is pointing in different directions. Before you go any further why not arrange some of the pieces in your room so that they are not all parallel. Hold your ruler or your sketch book at arm's length and look along the lines to discover how many vanishing points there are.

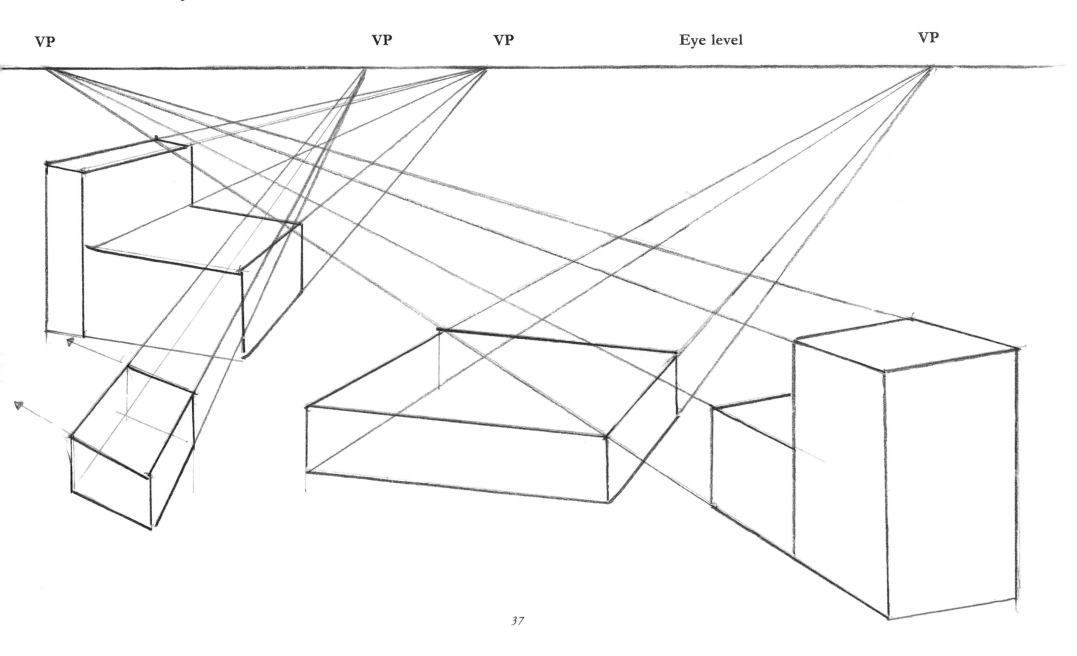

VP                                     VP         VP                  Eye level                    VP

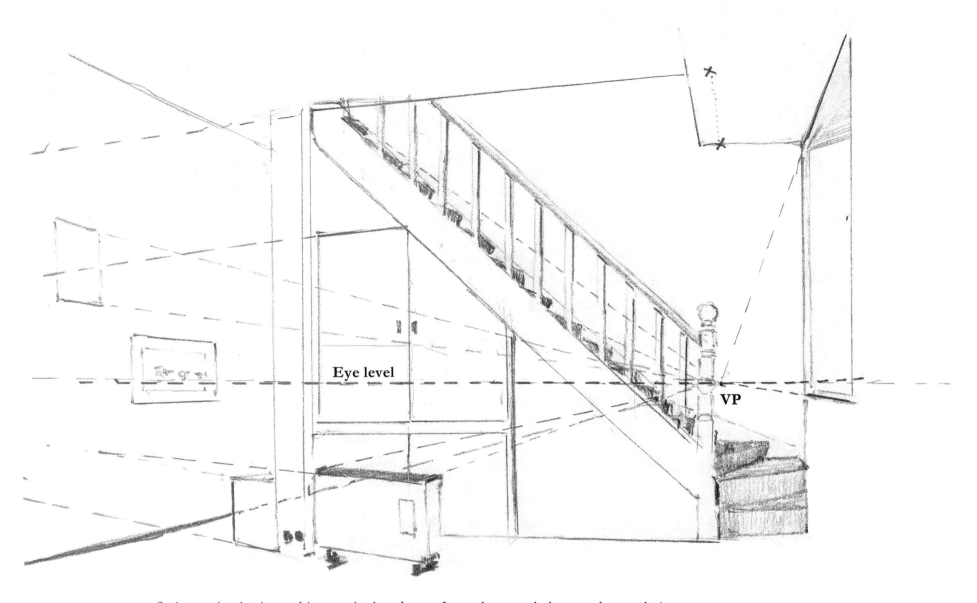

**Eye level**

**VP**

Stairs are intriguing subjects, whether drawn from above or below, and pose their own problems of perspective. In the earlier discussion of perspective, I said that there could be more than one vanishing point: here is an example. I was sitting on a chair and my eye level was as shown. However, if you look to the left you will see that the cupboard door, the electric heater and the ceiling above the stairs all project naturally towards the left to a VP along the eye level, but a long way beyond the drawing. The rest of the drawing leads you down to the central VP. Experiment with this, holding out a long ruler against non-vertical straight edges of items in the room. You will see how it all works out.

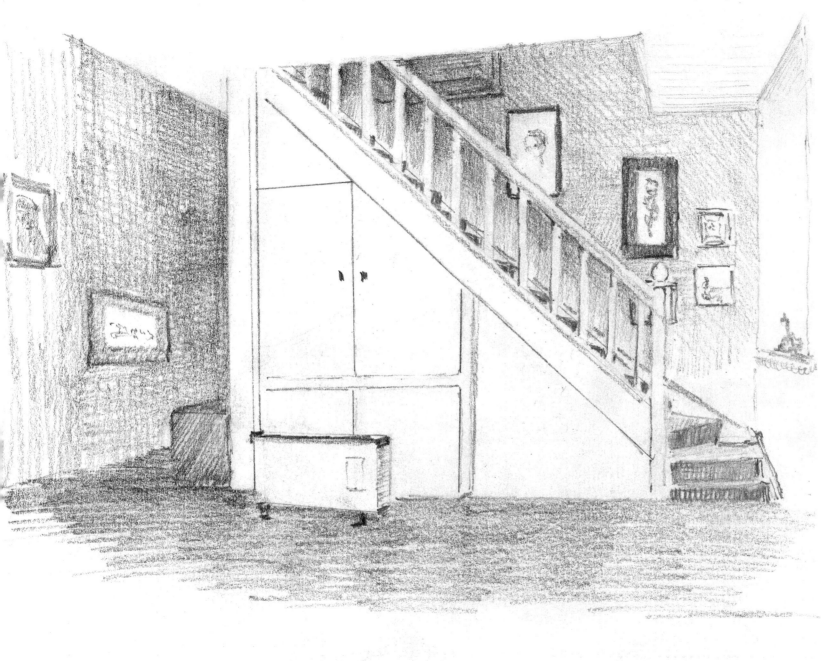

Here is the completed sketch. Lay a ruler along all the non-vertical lines and see whether you can find the vanishing points. Does my drawing reflect accurately what I have been saying?

Shading has played an important part. The first sketch which was completely flat established the position of the different angles in the room. When I began I used the small area between the Xs on the earlier sketch as my measuring scale. Holding my pencil upright at arm's length I measured that small piece of wall, then found that the handrail was five times as long, the top of the under-stair cupboard just slightly longer than my scale, and so on. The composition could have been improved by including a chair or a small table in the foreground but I have resisted doing this so as to make this a clear perspective exercise.

Sometimes a sketch will 'expand outwards' from a central theme. In this case I liked the flowered cushion on the chair and did an outline sketch, and then felt sufficiently confident to develop the drawing by including the chair, curtain and window. I didn't draw everything—I left out the carpet and only gave a suggestion of the tables.

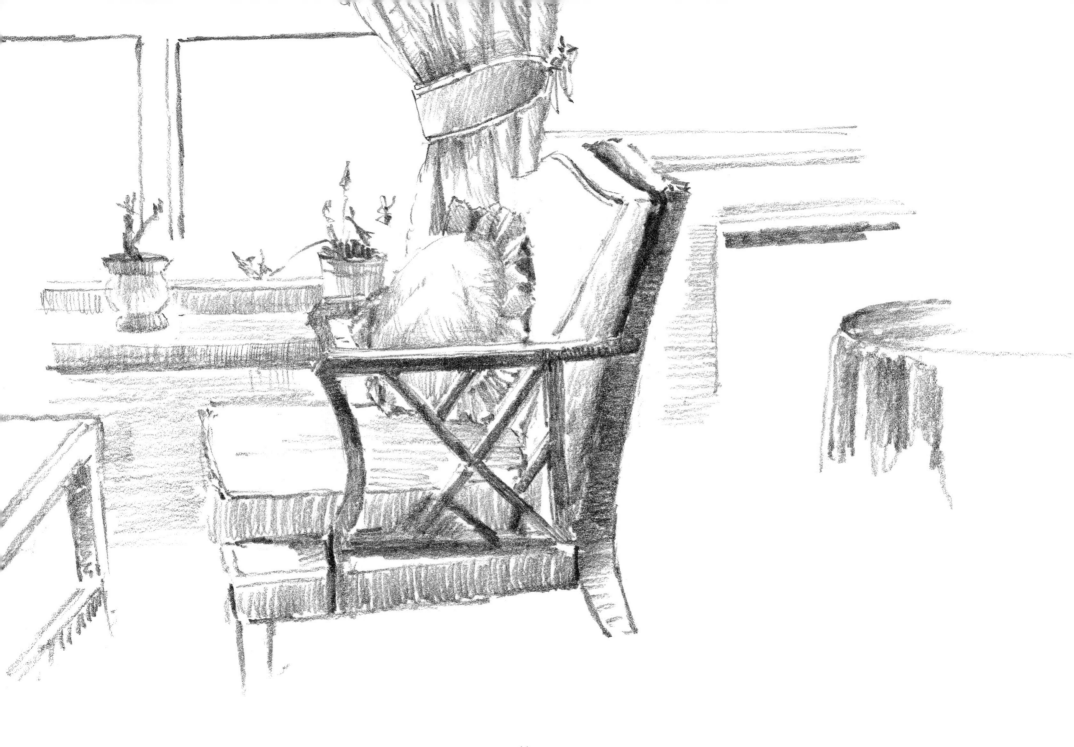

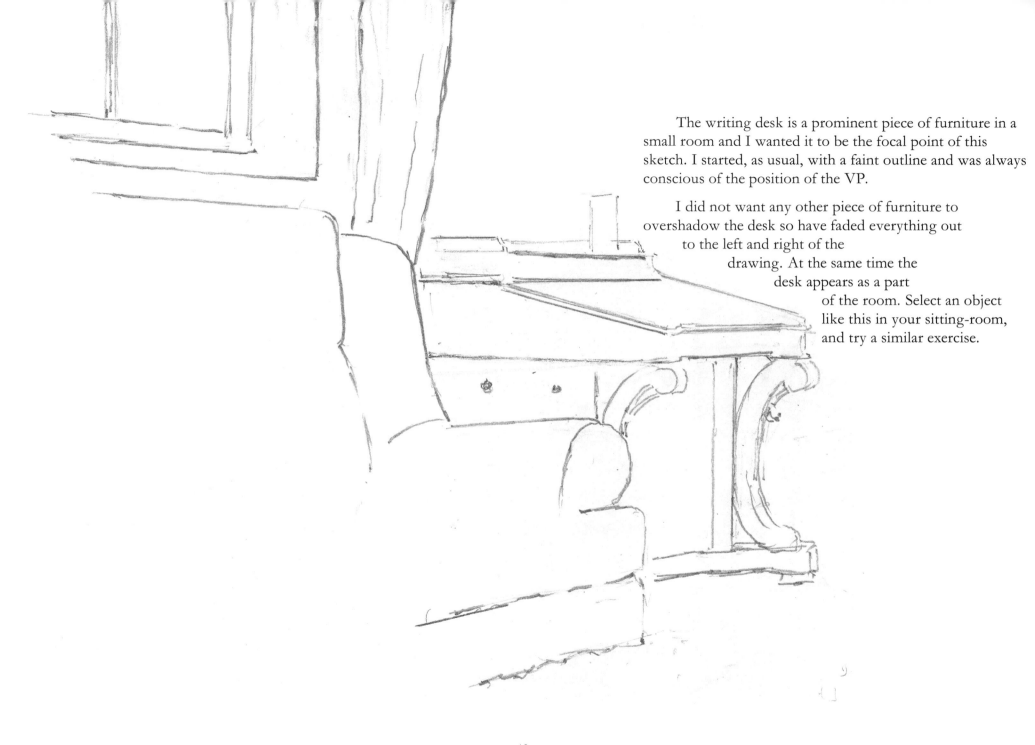

The writing desk is a prominent piece of furniture in a small room and I wanted it to be the focal point of this sketch. I started, as usual, with a faint outline and was always conscious of the position of the VP.

I did not want any other piece of furniture to overshadow the desk so have faded everything out to the left and right of the drawing. At the same time the desk appears as a part of the room. Select an object like this in your sitting-room, and try a similar exercise.

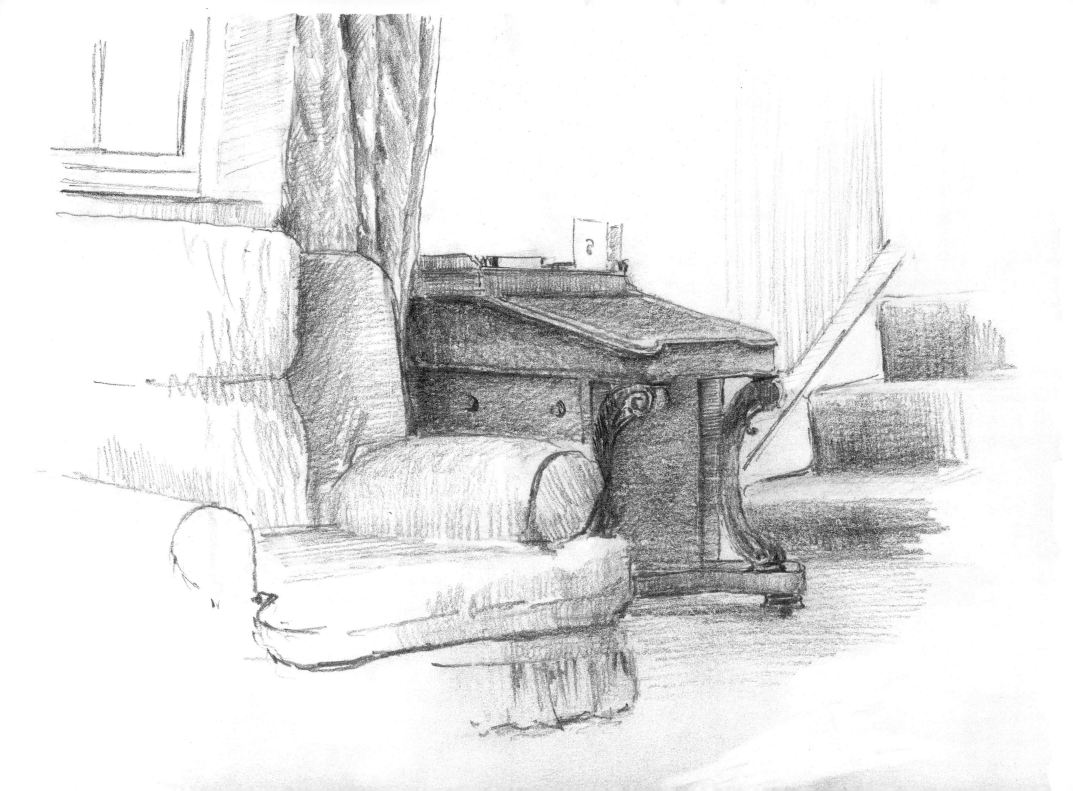

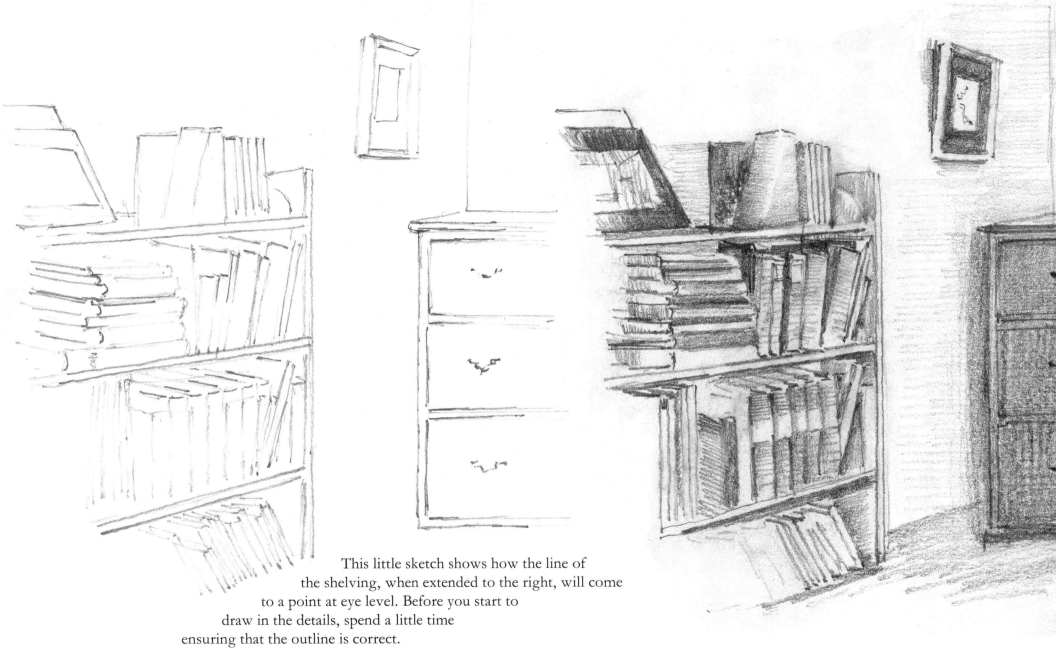

This little sketch shows how the line of
the shelving, when extended to the right, will come
to a point at eye level. Before you start to
draw in the details, spend a little time
ensuring that the outline is correct.
Shading will be much easier if you have sketched in the main features with a very light
touch. Once this is done you can bring it all to life with a 4B pencil.

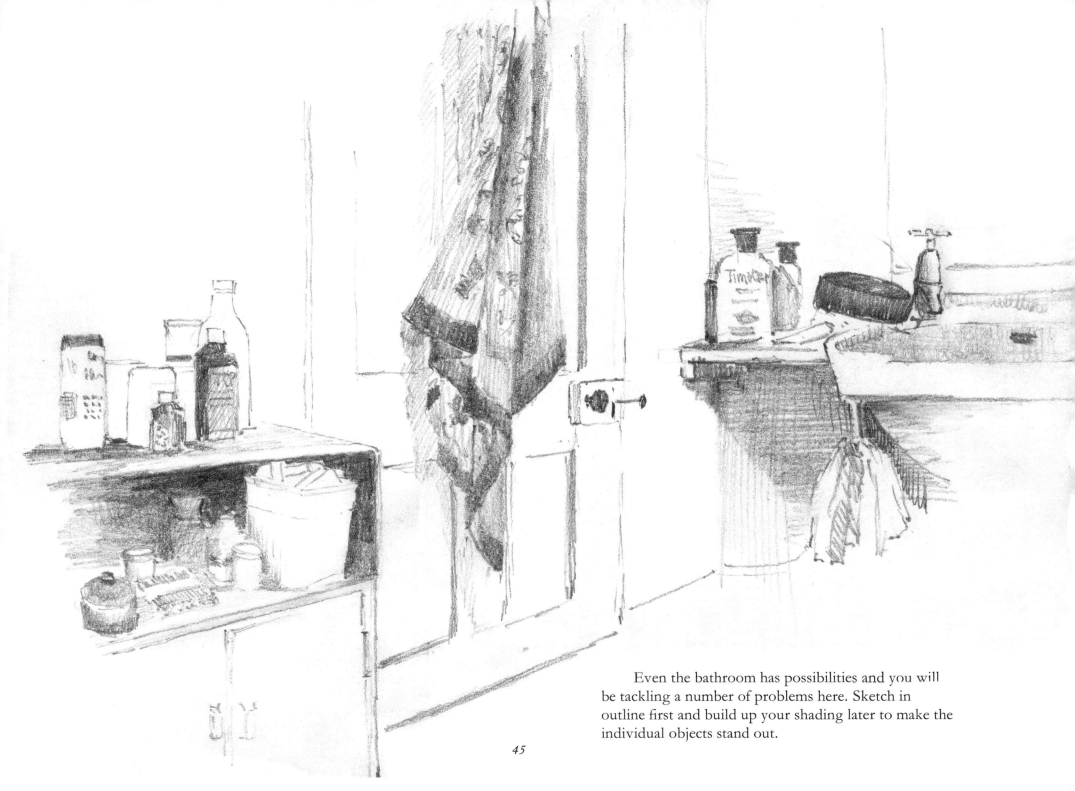

Even the bathroom has possibilities and you will be tackling a number of problems here. Sketch in outline first and build up your shading later to make the individual objects stand out.

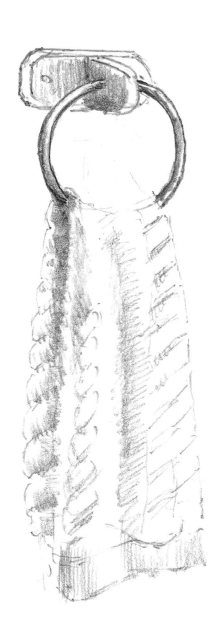
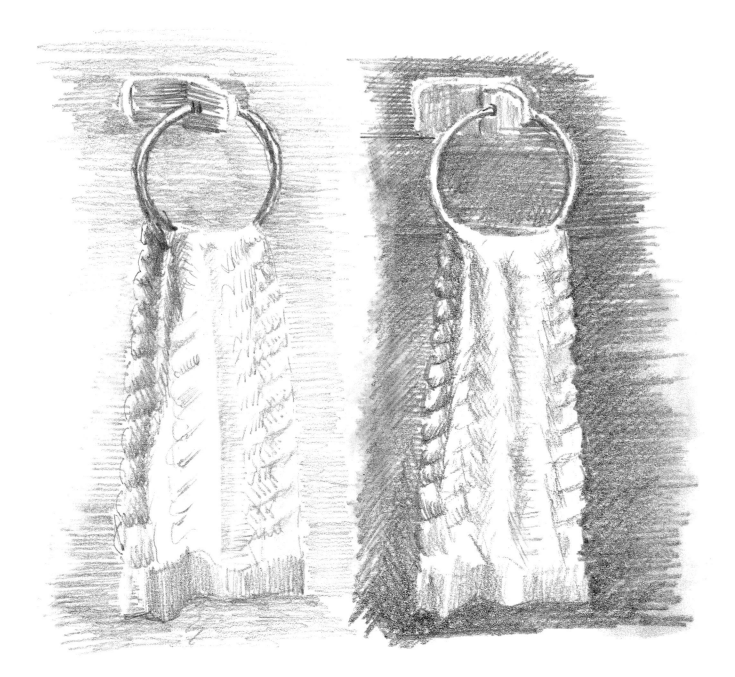

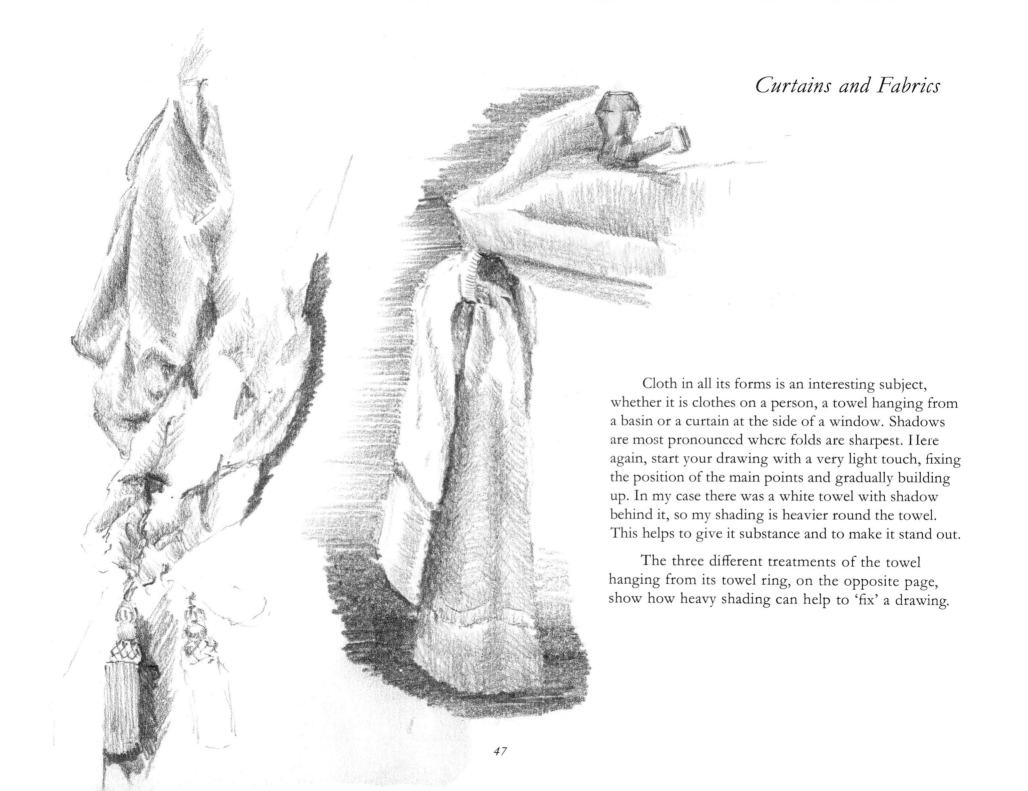

## Curtains and Fabrics

Cloth in all its forms is an interesting subject, whether it is clothes on a person, a towel hanging from a basin or a curtain at the side of a window. Shadows are most pronounced where folds are sharpest. Here again, start your drawing with a very light touch, fixing the position of the main points and gradually building up. In my case there was a white towel with shadow behind it, so my shading is heavier round the towel. This helps to give it substance and to make it stand out.

The three different treatments of the towel hanging from its towel ring, on the opposite page, show how heavy shading can help to 'fix' a drawing.

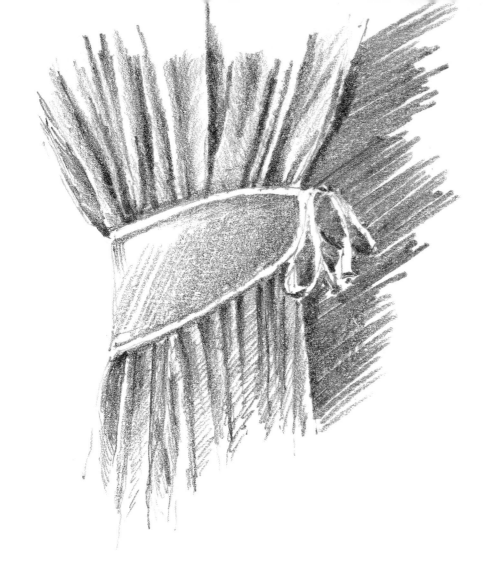

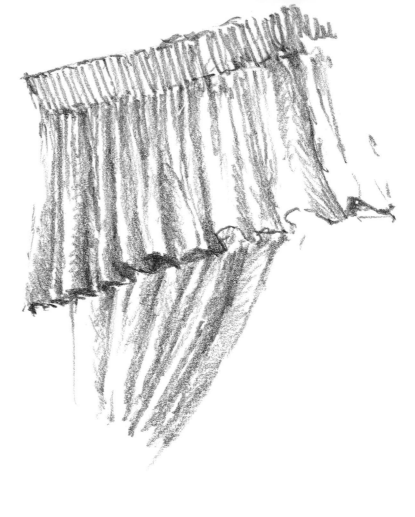

The soft folds in these curtains are captured here in simple
light and shade. In the pelmet on the right the depths of the folds
are generally shaded, while the forward curves of the material are
left white—an effective representation of the real thing.

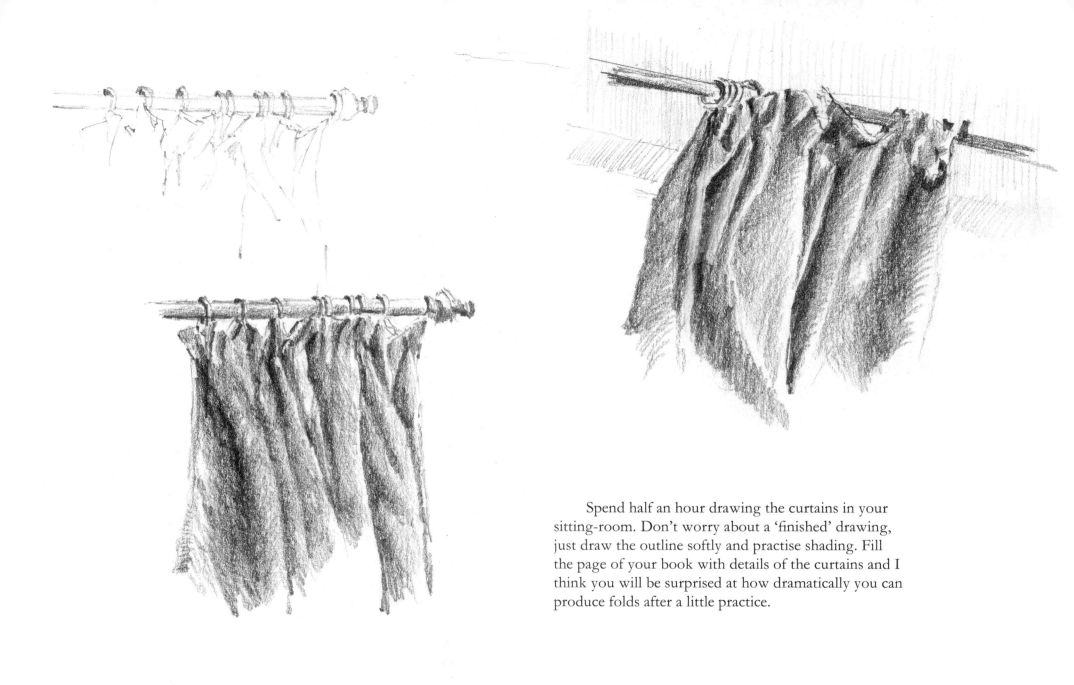

Spend half an hour drawing the curtains in your sitting-room. Don't worry about a 'finished' drawing, just draw the outline softly and practise shading. Fill the page of your book with details of the curtains and I think you will be surprised at how dramatically you can produce folds after a little practice.

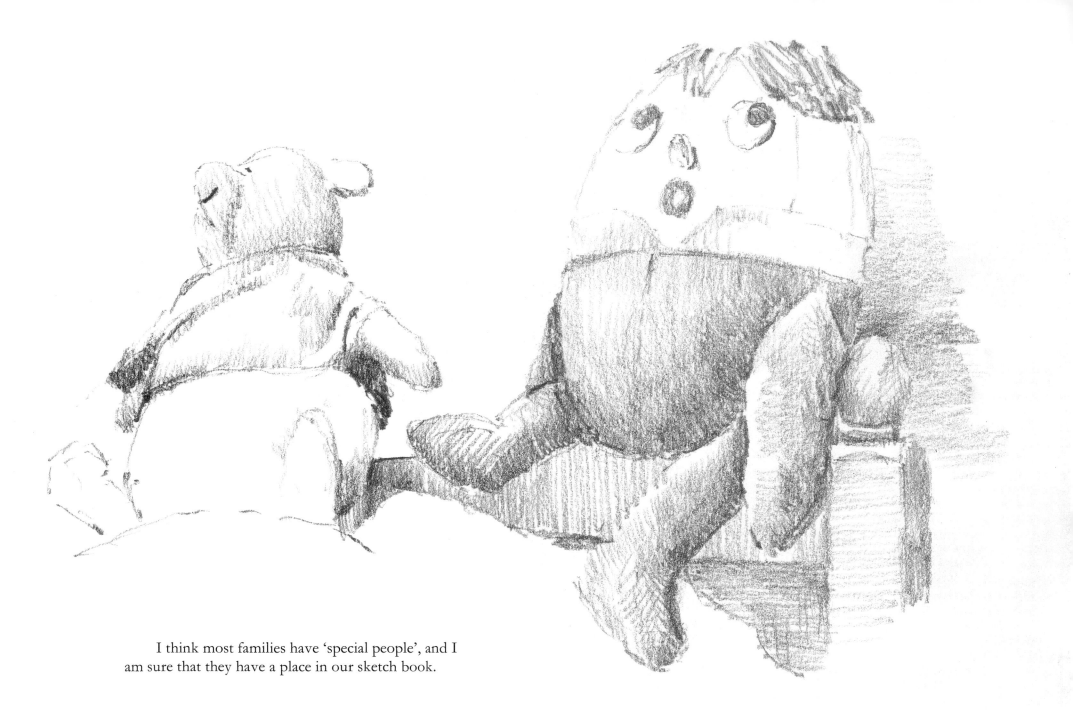

I think most families have 'special people', and I
am sure that they have a place in our sketch book.

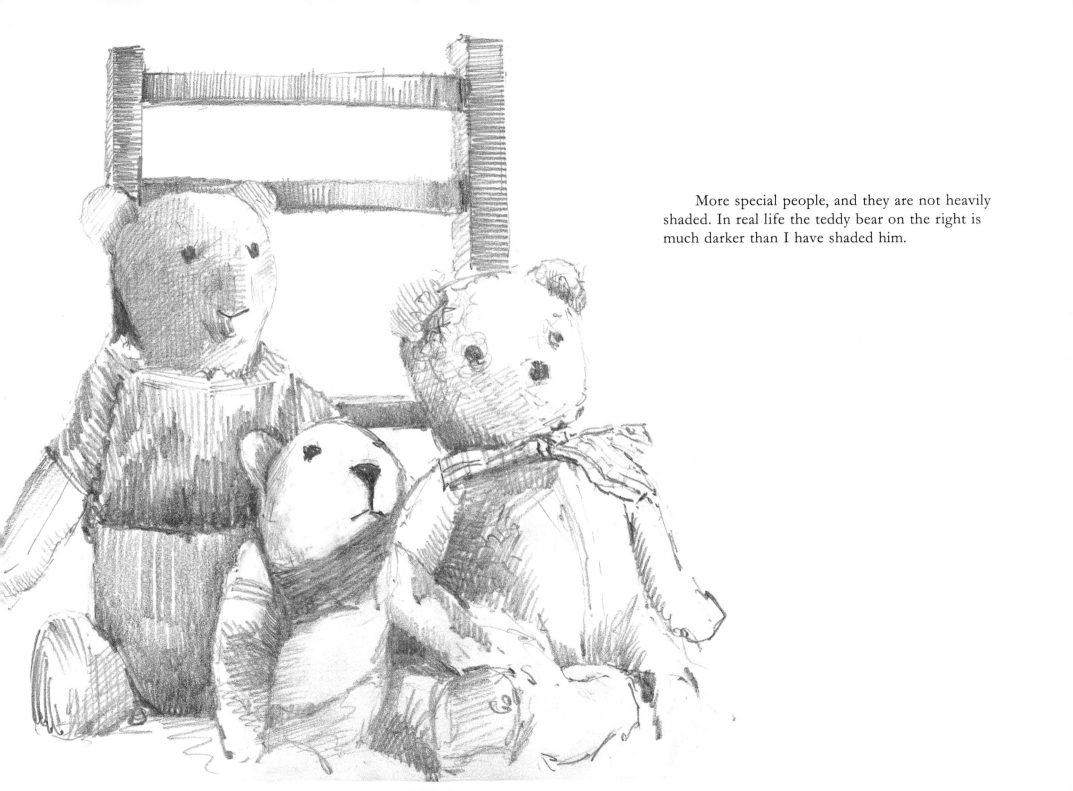

More special people, and they are not heavily shaded. In real life the teddy bear on the right is much darker than I have shaded him.

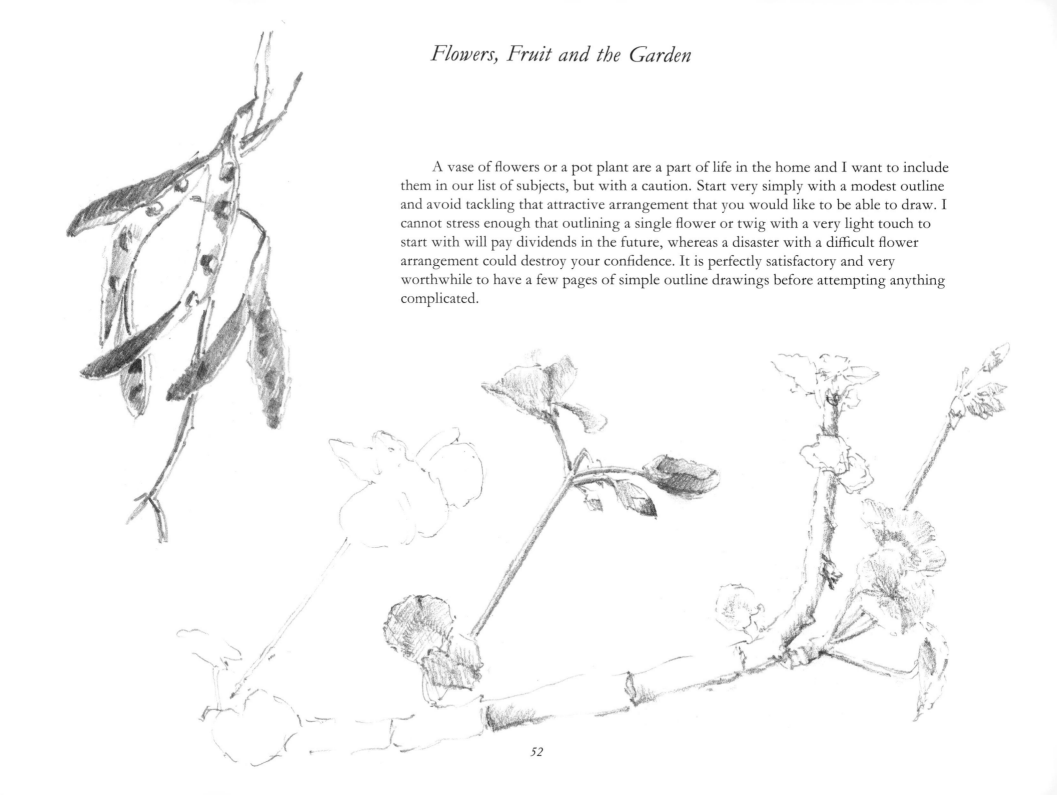

# Flowers, Fruit and the Garden

A vase of flowers or a pot plant are a part of life in the home and I want to include them in our list of subjects, but with a caution. Start very simply with a modest outline and avoid tackling that attractive arrangement that you would like to be able to draw. I cannot stress enough that outlining a single flower or twig with a very light touch to start with will pay dividends in the future, whereas a disaster with a difficult flower arrangement could destroy your confidence. It is perfectly satisfactory and very worthwhile to have a few pages of simple outline drawings before attempting anything complicated.

I sketched the outline of this cyclamen, trying to be accurate. It was a light pink flower against a darker background and I decided to use a 4B pencil to give some depth to this. Notice that I have graded my shading. I used a rubber to pick out the highlights — cleaning it after each stroke.

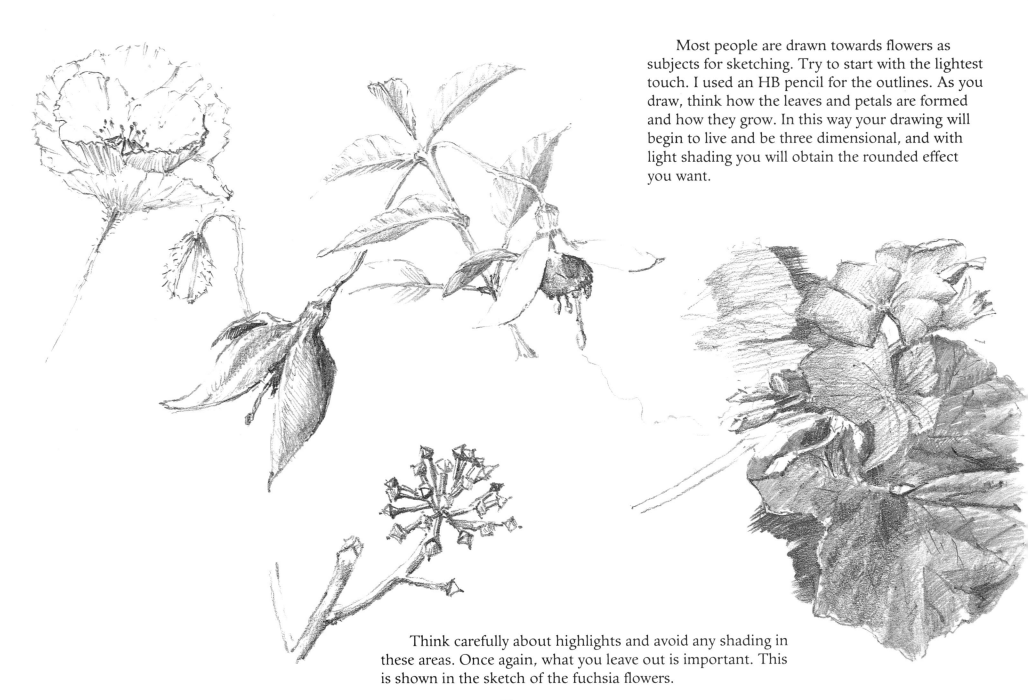

Most people are drawn towards flowers as subjects for sketching. Try to start with the lightest touch. I used an HB pencil for the outlines. As you draw, think how the leaves and petals are formed and how they grow. In this way your drawing will begin to live and be three dimensional, and with light shading you will obtain the rounded effect you want.

Think carefully about highlights and avoid any shading in these areas. Once again, what you leave out is important. This is shown in the sketch of the fuchsia flowers.

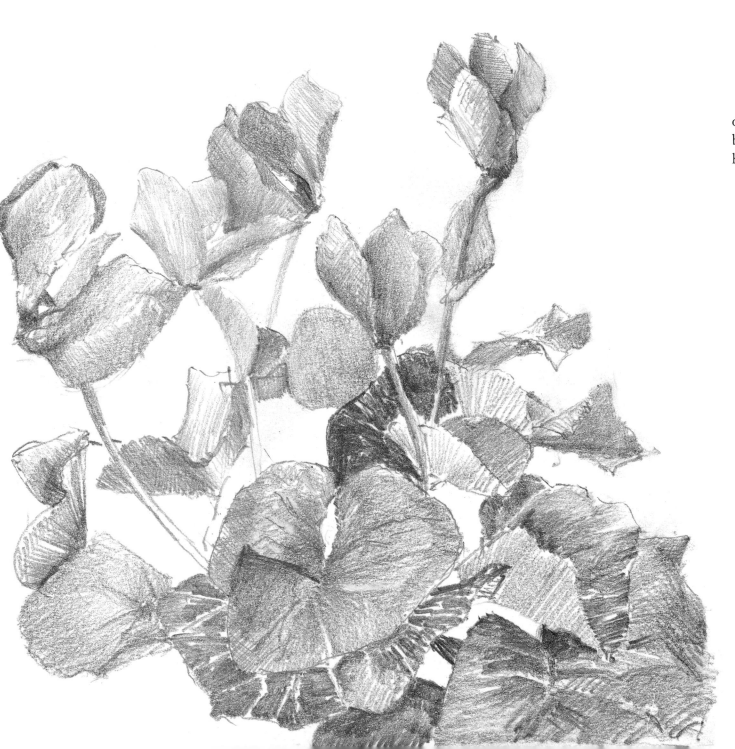

Be sure to draw a very light outline of each leaf and flower before you attempt to go on to heavier shading.

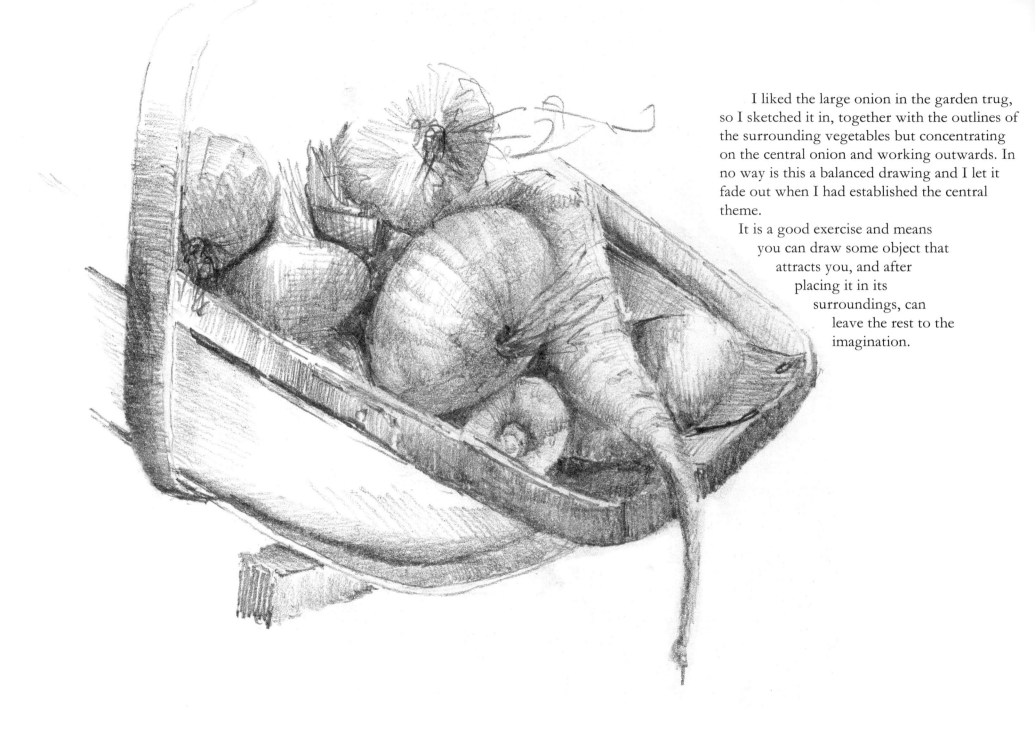

I liked the large onion in the garden trug, so I sketched it in, together with the outlines of the surrounding vegetables but concentrating on the central onion and working outwards. In no way is this a balanced drawing and I let it fade out when I had established the central theme.

It is a good exercise and means you can draw some object that attracts you, and after placing it in its surroundings, can leave the rest to the imagination.

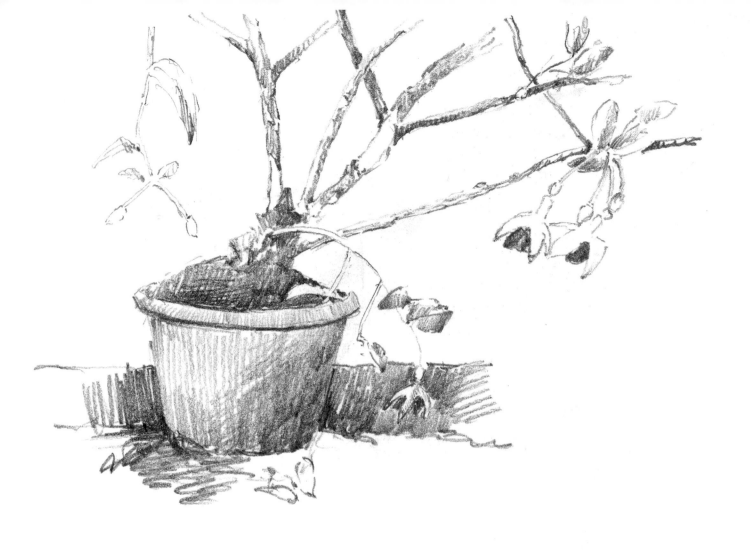

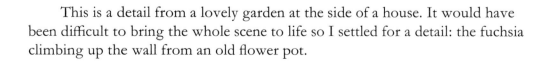

This is a detail from a lovely garden at the side of a house. It would have been difficult to bring the whole scene to life so I settled for a detail: the fuchsia climbing up the wall from an old flower pot.

Neither of these fruits is easy to draw, so why not start off with an outline and only draw a part of them. The pineapple leaves outlined very faintly and the shading was very controlled. You won't compose a masterpiece in the first week, so feel your way slowly.

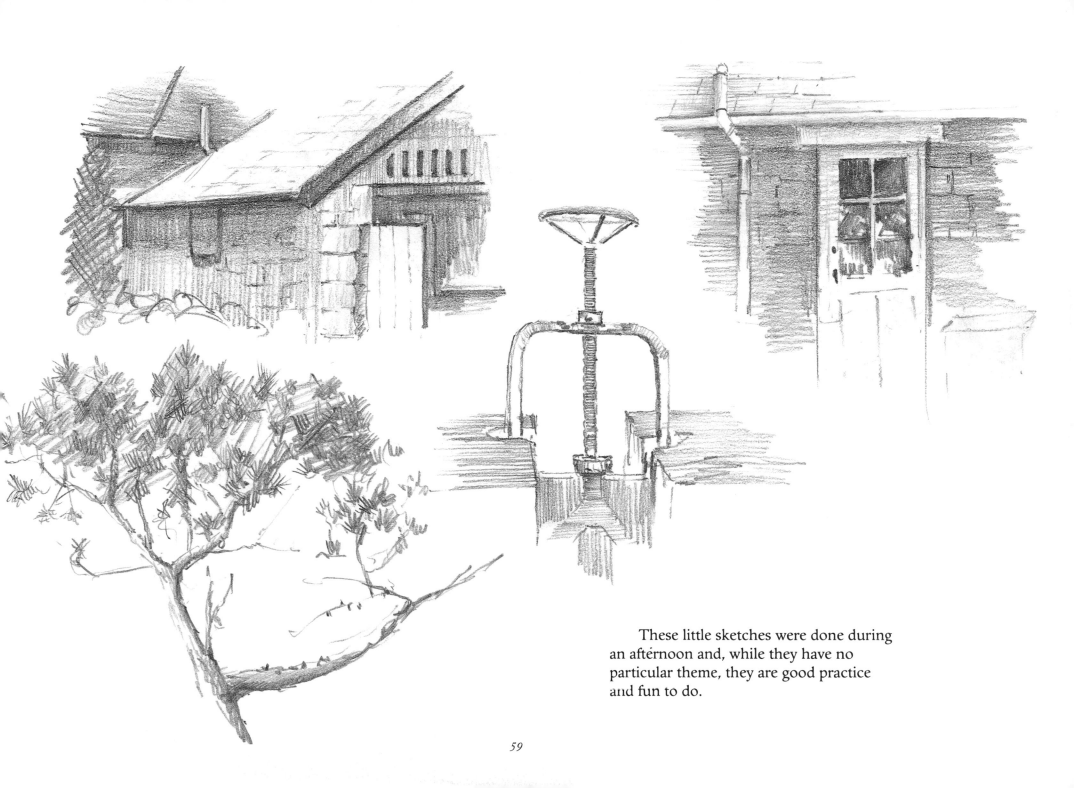

These little sketches were done during an afternoon and, while they have no particular theme, they are good practice and fun to do.

Before going out into the garden I looked at the back door of a nearby cottage. At first sight, this wooden structure at the back of a cottage might not seem a useful subject for a sketch, but I think it is. The shading inside the door gives a feeling of depth, and you will notice that I have decided to leave out the detail in the foreground to the right of the path, which was green grass.

Try to avoid the temptation to fiddle with extra shading; it is not necessary and will spoil your drawing.

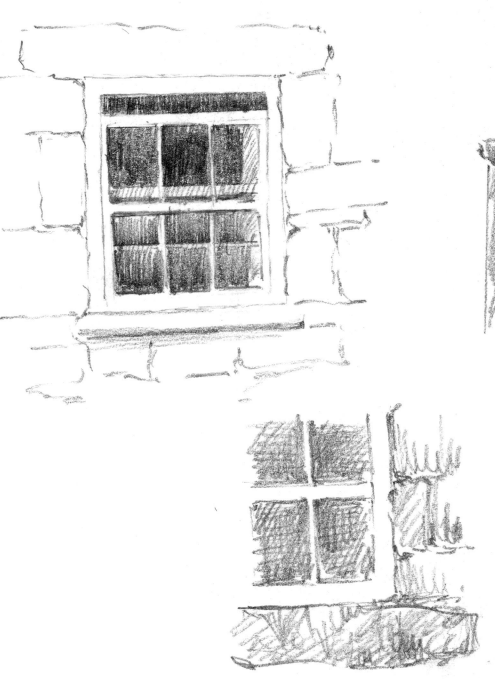

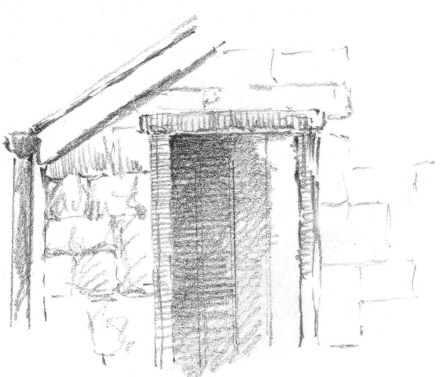

Once again I suggest that before you attempt a complete sketch of your home from the outside, you spend a little time on details of the building. Just fill a page with simple sketches. They will be a pleasing addition to your sketch book and will make you think about structure, but more important still, they will give you confidence.

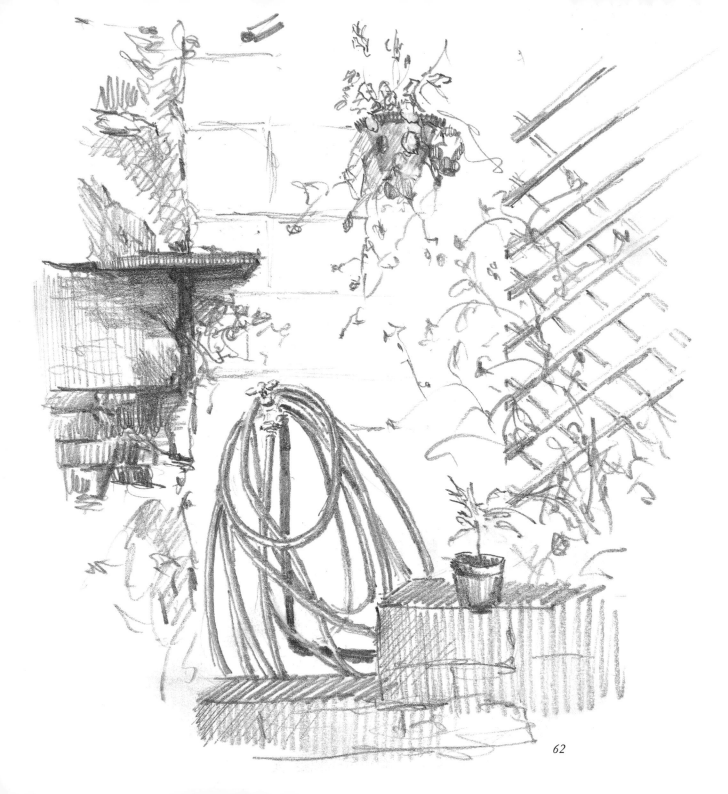

A corner with a garden hose. This is a case where you could select a central point—like the hose—and extend the drawing outwards to take in the surrounding flowers.

Try it yourself.

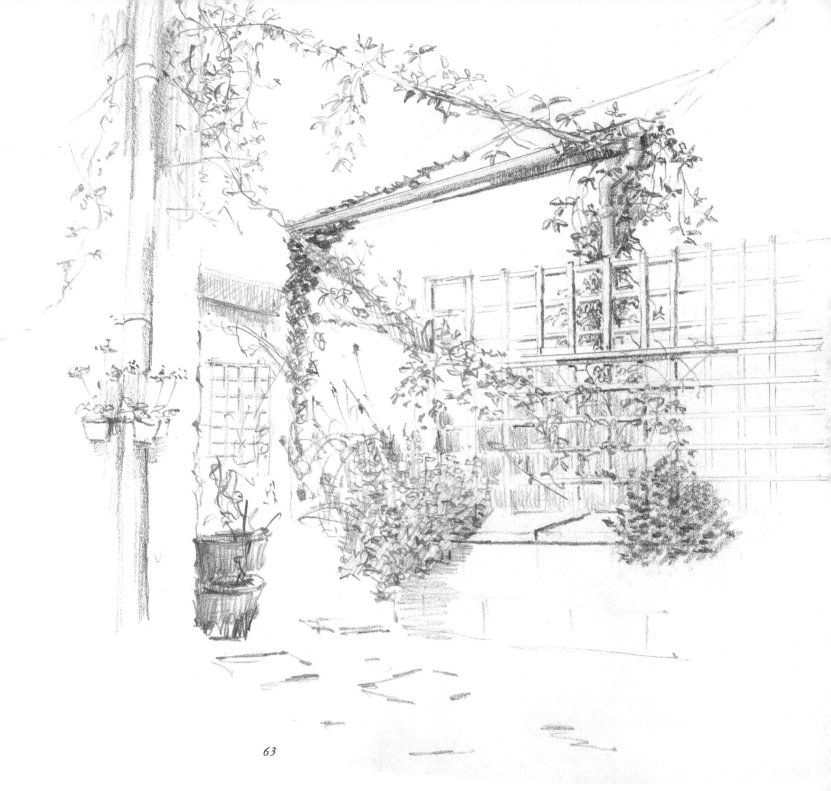

Whether you have a large garden, a small patio or just a window box, it will provide a subject for a sketch. This is a drawing of a very cleverly designed blaze of colour in a minute courtyard. If I had put in all the brickwork and every stem and leaf it would have become top heavy and would have missed the impression of brightness and colour that I wanted to give.

These two pages tell an important story. How far do I take my sketch?

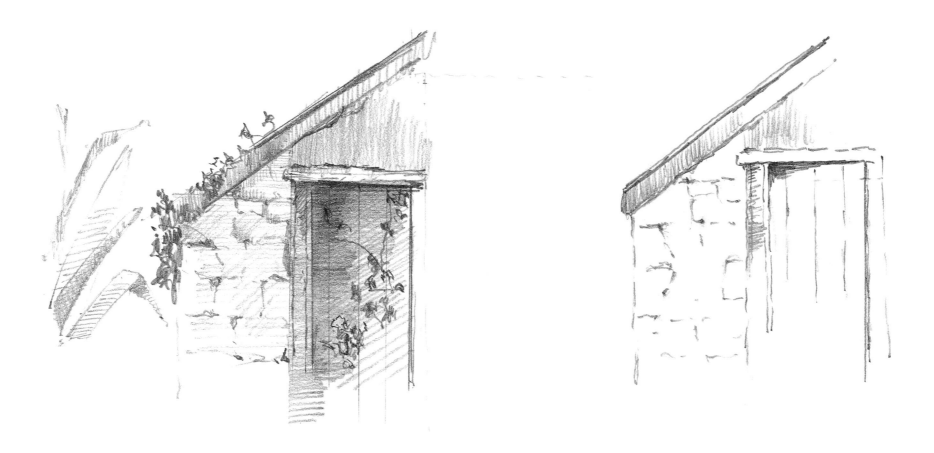

I think I can hear you say: 'That's not all that simple', but in fact it is. You can stop at any stage and it will be a pleasant subject to sketch. Either of these two little pictures could go into your sketch book. Remember how important it is to decide what to leave out. It is all too easy to go on an on until you have spoiled your work with too much detail.

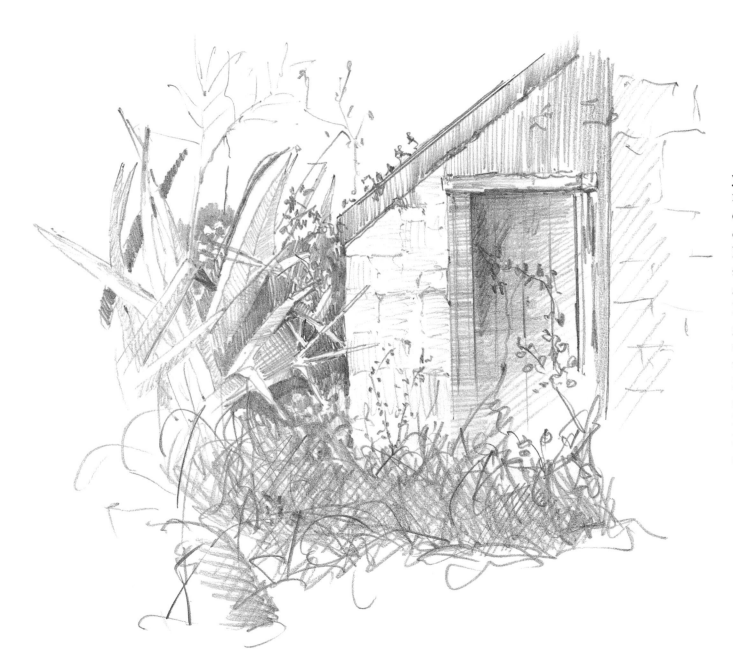

Let me try to convince you that you will have just as much fun sketching smaller details as you will from more complicated set-piece landscape drawings. At this stage choose subjects that are within your ability range. It may be an old shed or a gatepost or a wall, or even a detail from a house. With this more finished sketch I have accentuated parts by shading heavily, and have left other parts relatively light. Remember that shading can create depth.

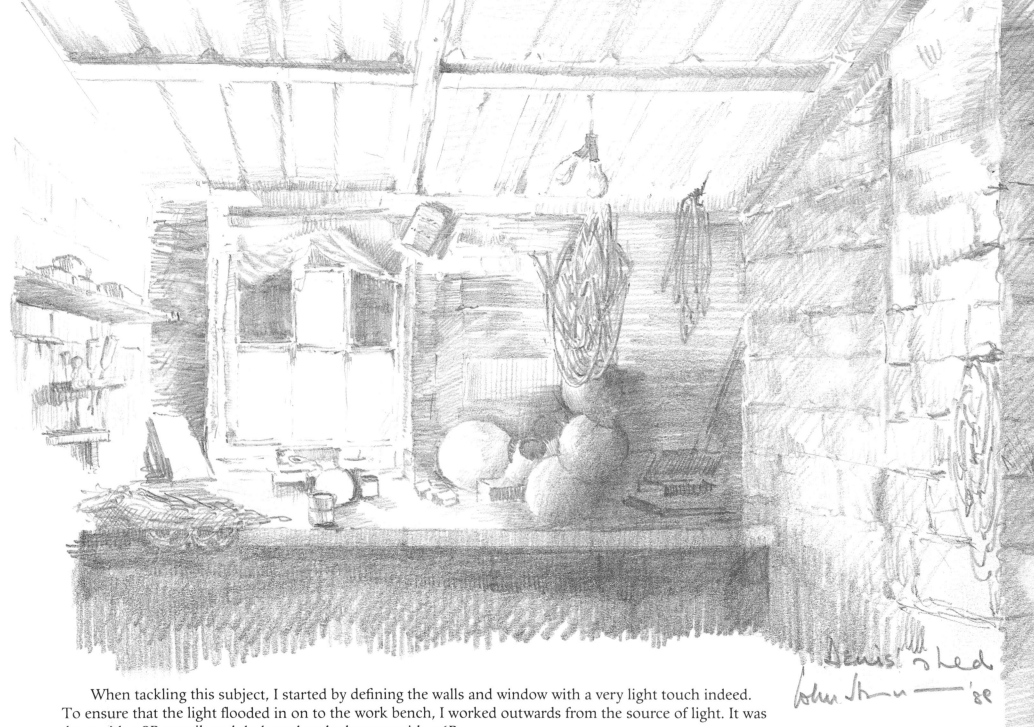

When tackling this subject, I started by defining the walls and window with a very light touch indeed. To ensure that the light flooded in on to the work bench, I worked outwards from the source of light. It was done with a 2B pencil, and darkened at the bottom with a 6B.

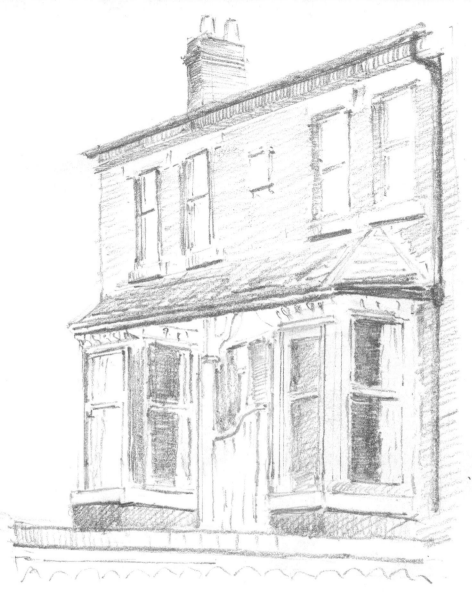

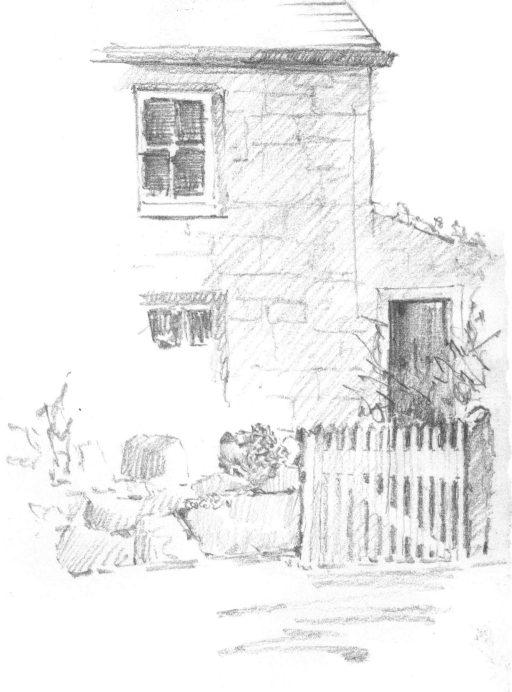

Try a complete sketch of the outside of your house — but again, don't aim to produce a 'finished' drawing: the essential features are all that you should attempt at this stage.

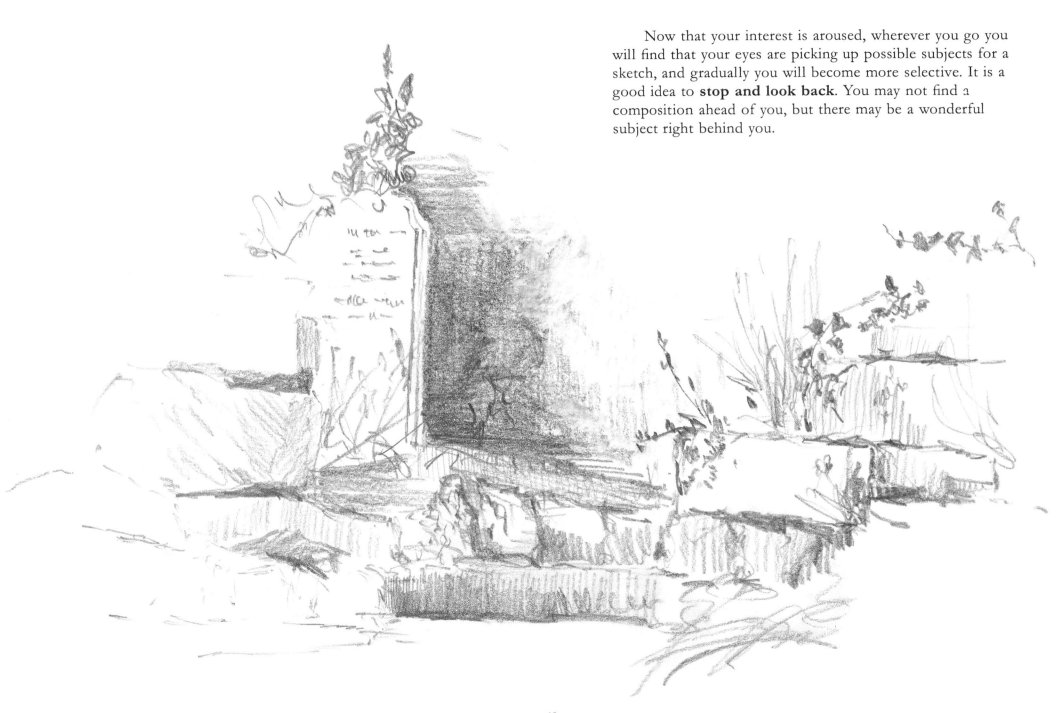

Now that your interest is aroused, wherever you go you will find that your eyes are picking up possible subjects for a sketch, and gradually you will become more selective. It is a good idea to **stop and look back**. You may not find a composition ahead of you, but there may be a wonderful subject right behind you.

Now let's start — but **please remember** — you are not going to try anything that is too difficult at first.

You are sitting in the countryside or on a beach and looking at the scene in front of you, trying to make up your mind what you will draw. Here is a hint. Take the outer box of a match box and put it to your eye. Better still cut a rectangle out of a piece of card.

What you see is the area that will fill your page. Have you ever thought that it is only when your eyes concentrate on a particular tree or wall or bush that you are aware of the intricate detail. Otherwise there is only a general form of landscape. So what you decide to leave out is almost as important as what you put in.

Forget the detail for a moment, and consider where you are going to place the horizon in your first sketch.

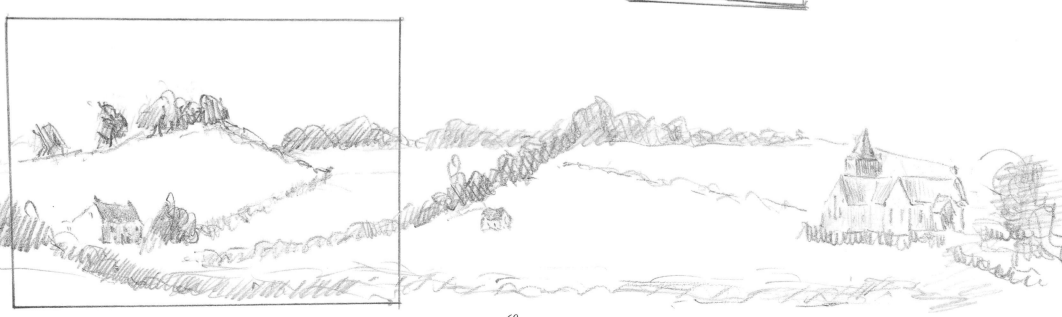

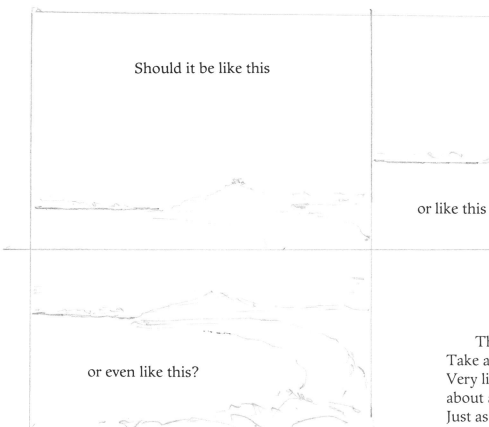

Should it be like this

or like this

or even like this?

Think carefully about this before you start your drawing. Take a 2B pencil and draw one or two rectangles like I have. Very lightly sketch in the scene in front of you. Don't worry about accuracy, and don't press hard. Keep it light and simple. Just as I have and no darker.

Two things are happening. Firstly you are thinking about your composition and the limits of what you can put down on the paper—remembering to look through the frame you made just now, or the match box. Secondly you are relaxing and your wrist and forearm are becoming supple.

You are drawing hardly more than a series of doodles, but you are learning a lot and composing your sketch.

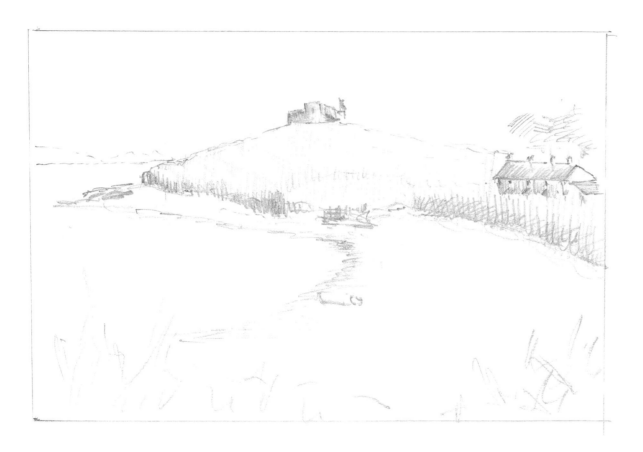

You have decided where to place the horizon — in my case a quarter of the way down from the top of the page. It has gone in lightly with a 2B. In this way I can relate the hill, the castle and the foreground to my line of horizon. It is only in outline, and at this stage we are not trying to produce a masterpiece — just a preliminary thumbnail sketch.

The outline is in and we can now start some shading. There are few rules, but in general the further away into the distance you are, the lighter the shading.

I finished the sketch and ended up using a 4B and a 6B pencil in the foreground. Study carefully what I must have left out. There are no clouds and the sea is untouched. I have tried to make a difference between the islands in the distance and the foreground. We are always striving to give a three dimensional effect to a flat surface. This is not a finished drawing — it is a sketch, and I hope you will have great fun and satisfaction in filling your sketch book with the results of your work.

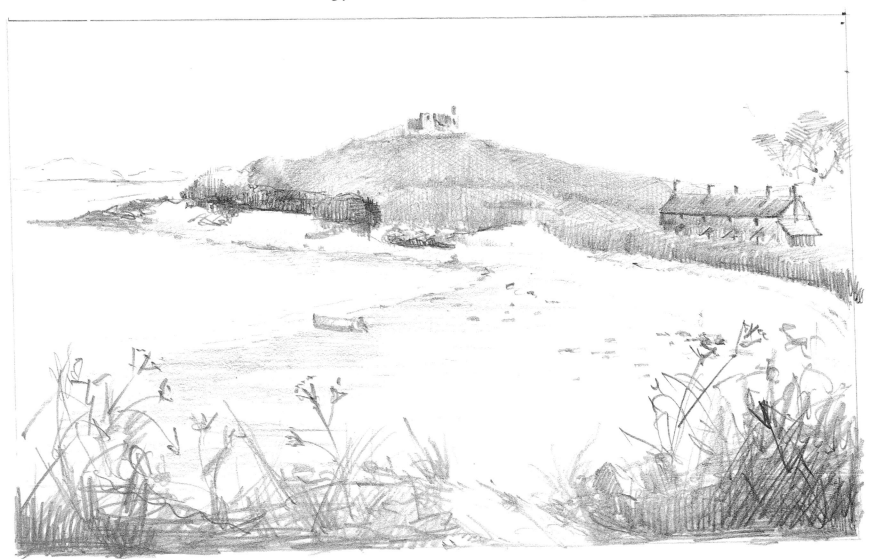

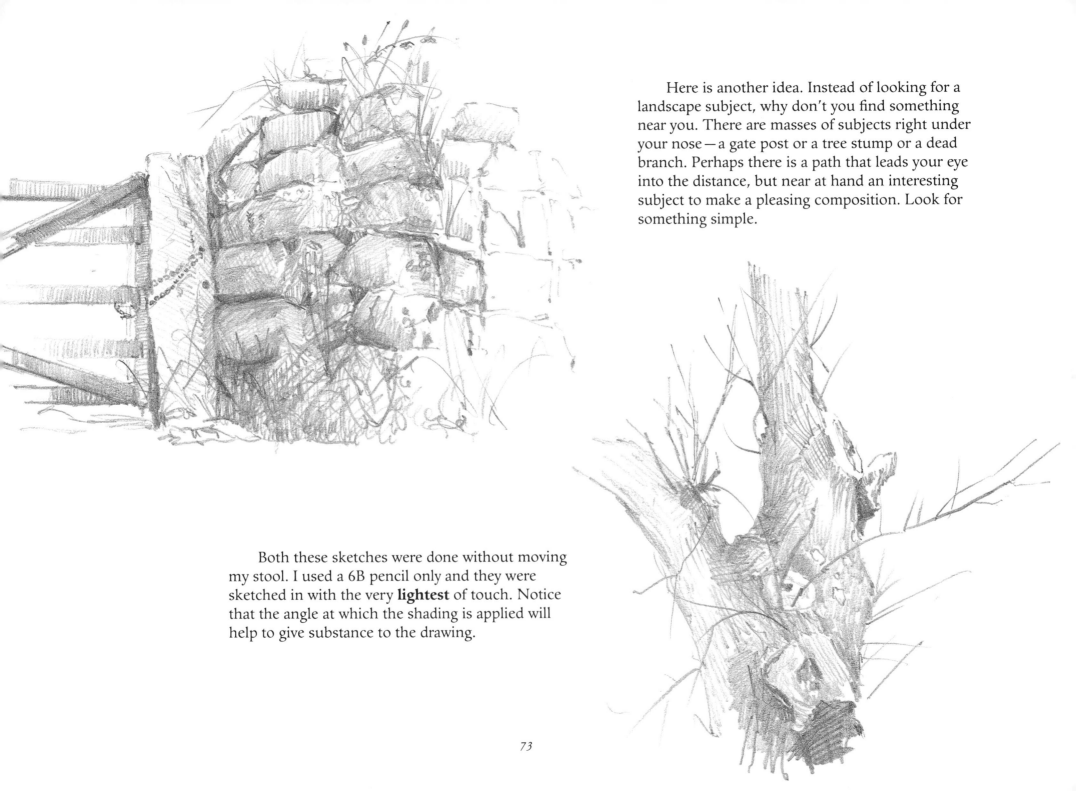

Here is another idea. Instead of looking for a landscape subject, why don't you find something near you. There are masses of subjects right under your nose—a gate post or a tree stump or a dead branch. Perhaps there is a path that leads your eye into the distance, but near at hand an interesting subject to make a pleasing composition. Look for something simple.

Both these sketches were done without moving my stool. I used a 6B pencil only and they were sketched in with the very **lightest** of touch. Notice that the angle at which the shading is applied will help to give substance to the drawing.

73

It is time to become a little more critical. Study the composition of these two sketches. I didn't have to move very far, but they are both different. In future, I hope that you will be looking at subjects as compositions for a sketch. When you are browsing through your photographs, or indeed when you are about to take a photograph, try to think of compositions. The same is true for reproductions in magazines and books, and when you are looking at a painting. Ask yourself, 'Do I like this composition, or could it be improved?' Now do the same when you are out of doors, and always be on the lookout for a simple but effective composition. When you are considering a subject, move fifty yards to either side and see if the composition is improved. Which part of the scene appeals to you most? In this case, is it the porch or the rose window or the gravestones in the foreground?

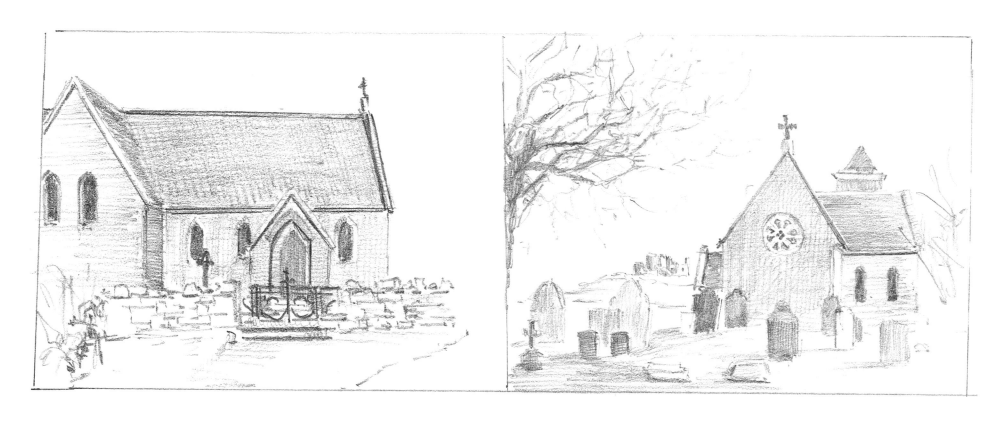

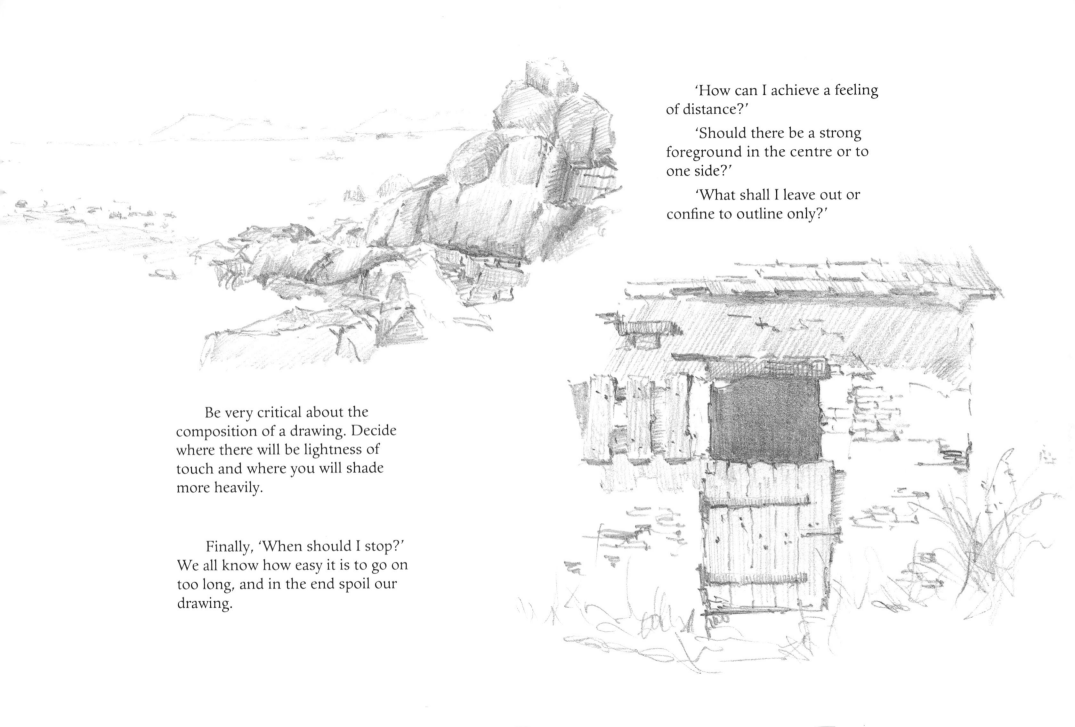

'How can I achieve a feeling of distance?'

'Should there be a strong foreground in the centre or to one side?'

'What shall I leave out or confine to outline only?'

Be very critical about the composition of a drawing. Decide where there will be lightness of touch and where you will shade more heavily.

Finally, 'When should I stop?' We all know how easy it is to go on too long, and in the end spoil our drawing.

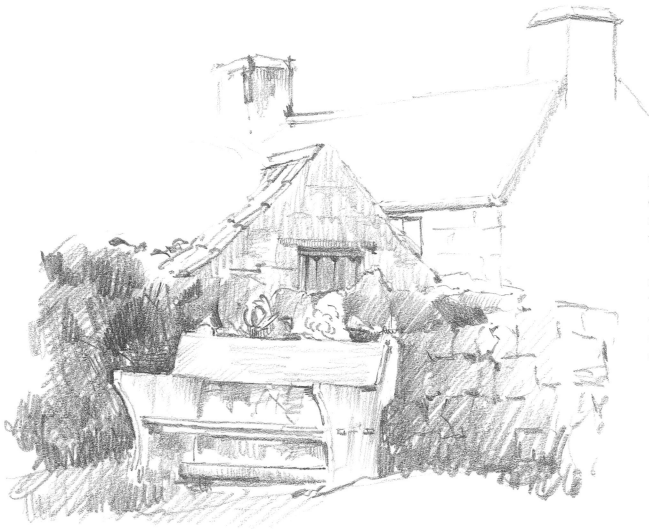

If I had drawn the house in detail it would have overshadowed the seat and the old outhouse. Instead, I started by sketching in the main features **very** lightly with a 2B pencil, and then shaded round the seat to bring it forward.

The full strength of my 6B pencil was used round the edge of parts of the seat. Then I tried to give a feeling of separate identity firstly of the seat, then the wall behind it, then the outhouse with its door, and finally the outline of the house.

At this stage I want to reintroduce our old friend PERSPECTIVE. It can be a little daunting, but I want to suggest some very basic thoughts. Firstly, objects tend to converge and diminish as they recede into the distance. When they actually disappear at the horizon, they are said to have reached the vanishing point. A line of trees or a railway track are good examples of this.

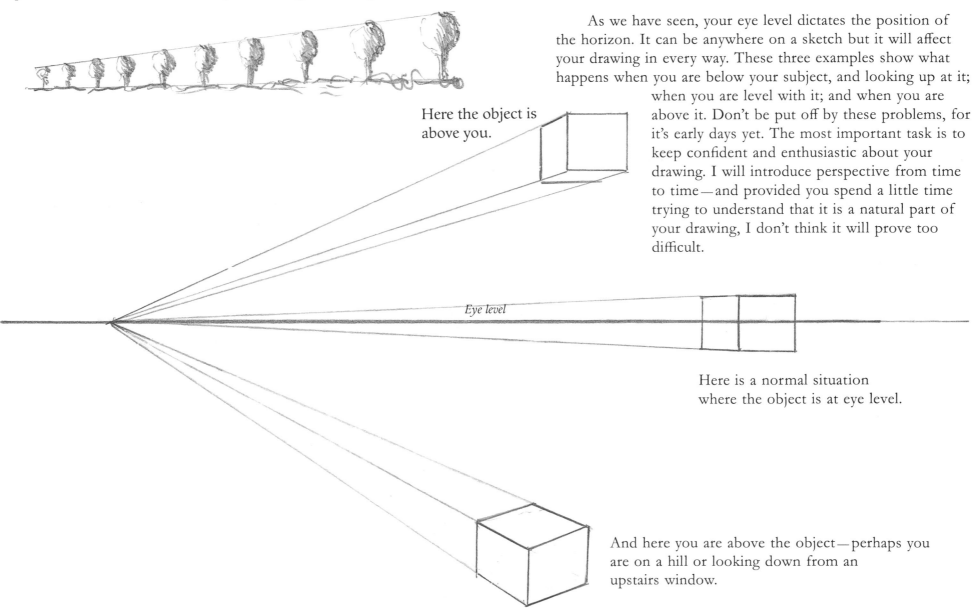

As we have seen, your eye level dictates the position of the horizon. It can be anywhere on a sketch but it will affect your drawing in every way. These three examples show what happens when you are below your subject, and looking up at it; when you are level with it; and when you are above it. Don't be put off by these problems, for it's early days yet. The most important task is to keep confident and enthusiastic about your drawing. I will introduce perspective from time to time—and provided you spend a little time trying to understand that it is a natural part of your drawing, I don't think it will prove too difficult.

Here the object is above you.

*Eye level*

Here is a normal situation where the object is at eye level.

And here you are above the object—perhaps you are on a hill or looking down from an upstairs window.

We will start now with a collection of buildings. You may be in the country or in a town, but the principle is the same. Think from where you would like to sit to do your drawing. You are composing your picture, and I hope using your matchbox or viewer. Try to keep it simple and maybe do one or two light drawings to block in where the outline and rooftops will come. A light line across the page to show the eye level and thus the vanishing points will save you a lot of problems. Here are some step by step stages from a drawing.

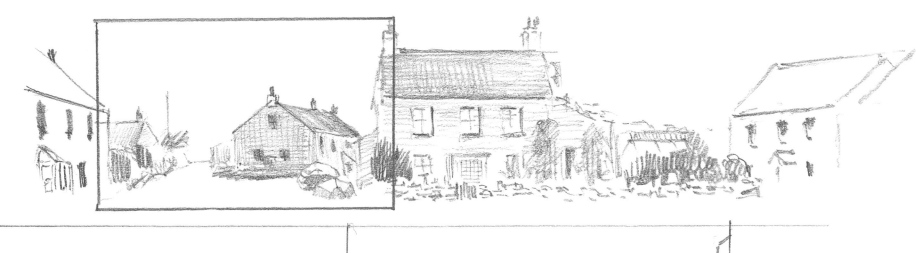

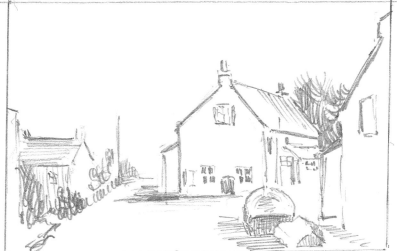

Spend a moment or two looking at this drawing. If I had included the granite stone in the end wall of the facing cottage it would have destroyed the feeling of sunlight (which is accentuated by the shadows). The cottage in the distance on the left is brought to life with the shrubs and trees that surround it. The roadway is in sunlight and the boats are a lucky composition bonus. Note that I have only given the barest indication of the granite wall on the right. Finally—there was no need to make any shading in the sky. This is what I mean by deciding what to leave out.

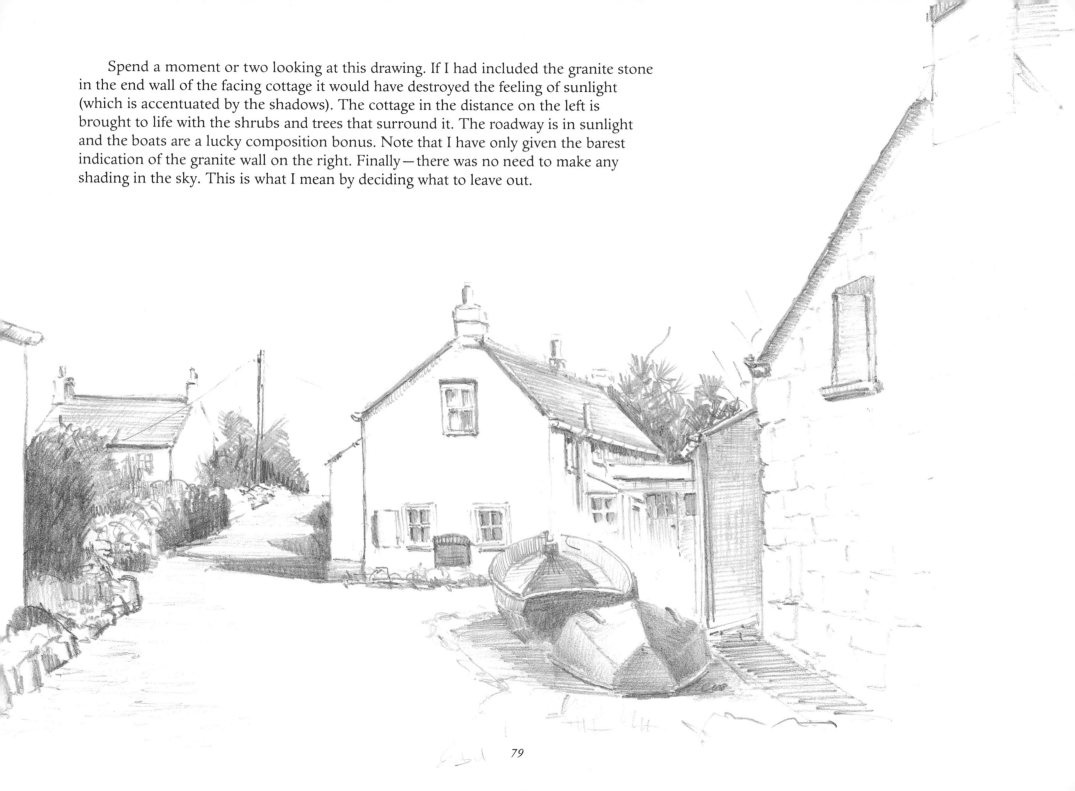

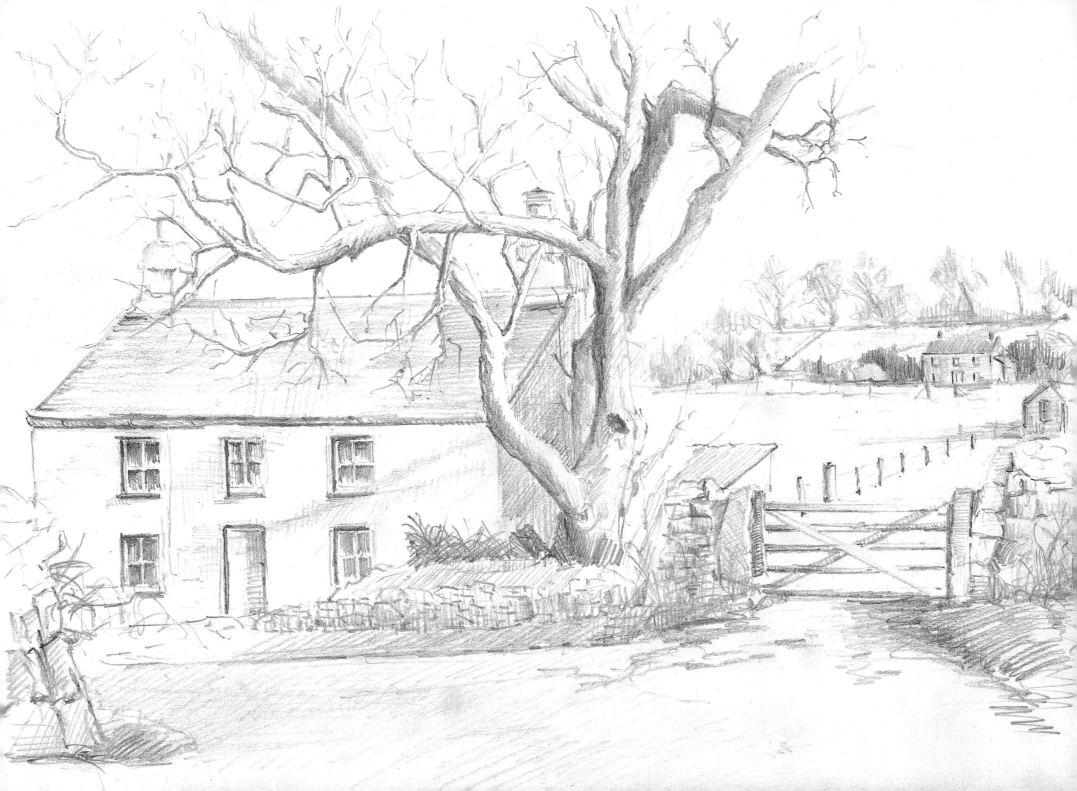

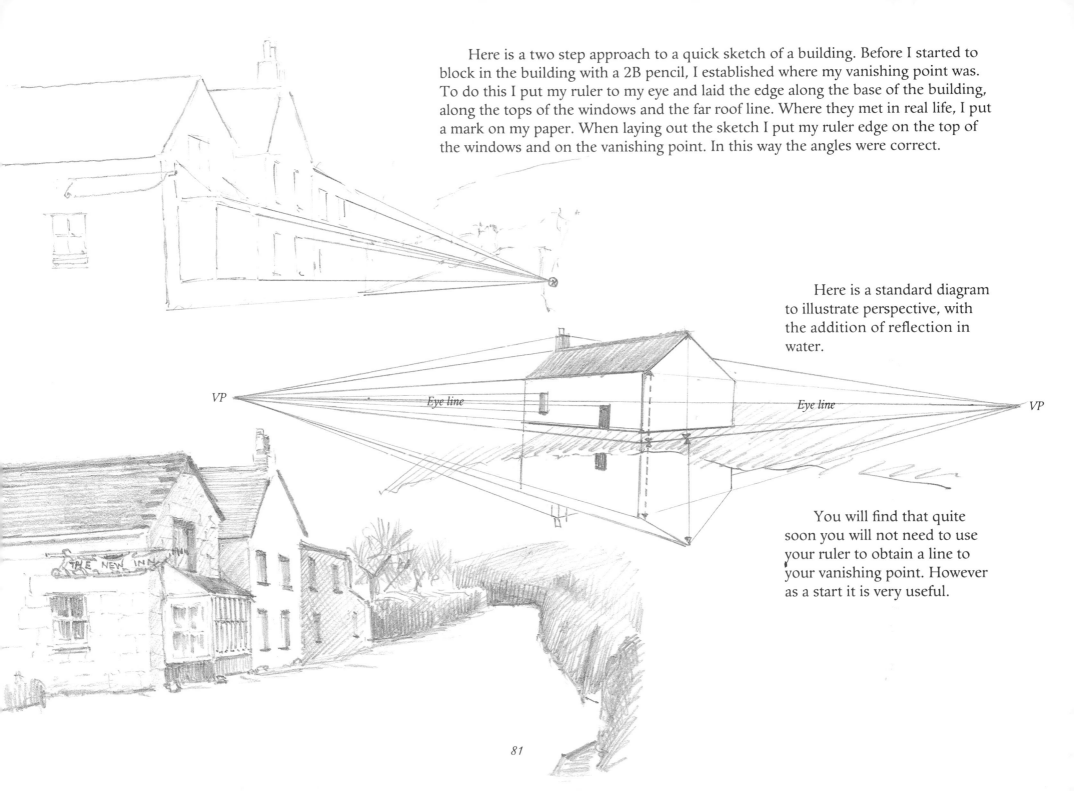

Here is a two step approach to a quick sketch of a building. Before I started to block in the building with a 2B pencil, I established where my vanishing point was. To do this I put my ruler to my eye and laid the edge along the base of the building, along the tops of the windows and the far roof line. Where they met in real life, I put a mark on my paper. When laying out the sketch I put my ruler edge on the top of the windows and on the vanishing point. In this way the angles were correct.

Here is a standard diagram to illustrate perspective, with the addition of reflection in water.

*VP*

*Eye line*

*Eye line*

*VP*

You will find that quite soon you will not need to use your ruler to obtain a line to your vanishing point. However as a start it is very useful.

Contrasts in shading— they could both go into your sketch book, but if you continued to shade the left-hand sketch you might lose some of the lightness.

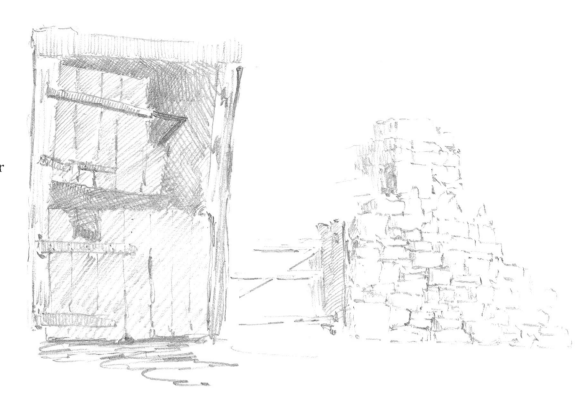

The collection of barns sketched on the opposite page gives further examples of what to accentuate and what to leave out. The roof of the farmhouse on the left remains in outline only, while the trees behind the cowshed roof are very dark. They push the roofs forward. There is no need to try to draw every branch of the trees. Not only will it be very difficult but it will probably result in them becoming overpowering. Remember that in real life you don't see all the details—it is only when your eye rests on an object that you actually **see** the individual twigs and small branches. In this case you are looking at a scene.

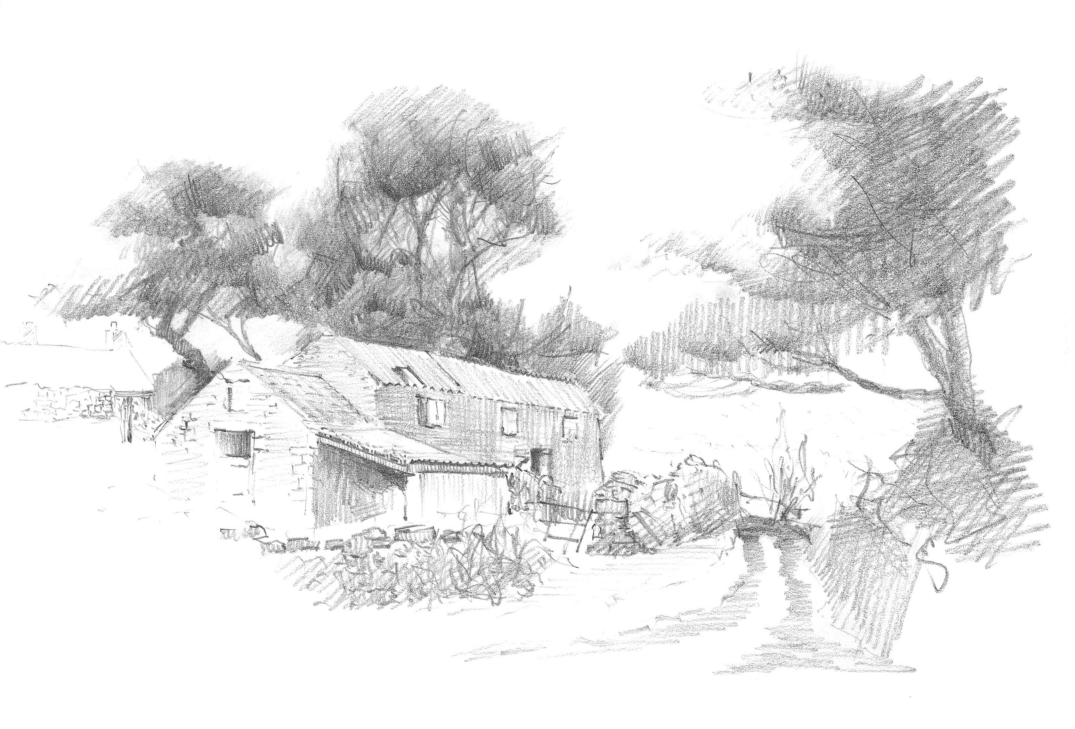

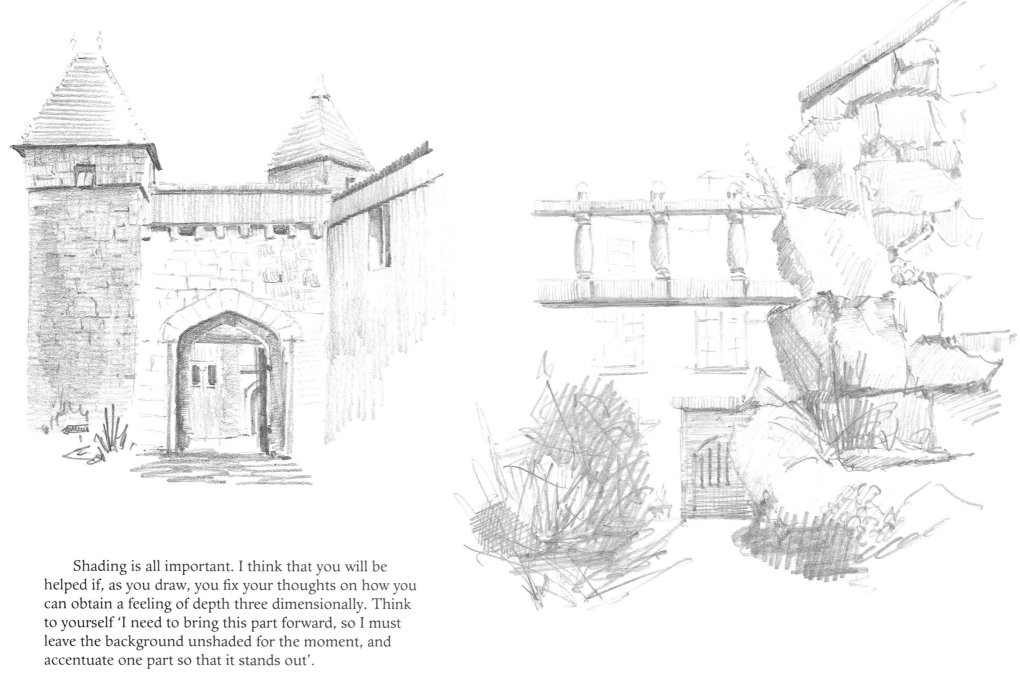

Shading is all important. I think that you will be helped if, as you draw, you fix your thoughts on how you can obtain a feeling of depth three dimensionally. Think to yourself 'I need to bring this part forward, so I must leave the background unshaded for the moment, and accentuate one part so that it stands out'.

Don't worry, it will all come with practice.

This half completed sketch of the other side of the gateway brings out one or two more points. A very light touch with an HB pencil has blocked in the outlines. I used my rubber two or three times before I got the proportions correct. The decision about what to leave out must now be taken. The big fir tree on the left is helping to bring the building forward — but the effect will be lost if we shade the building too much.

How can I get a feeling of distance when looking through the gateway? Possibly either by deep shading inside the gateway and suggesting trees visible on the left through the archway. However I would lose everything if there was too much detail and it became fussy.

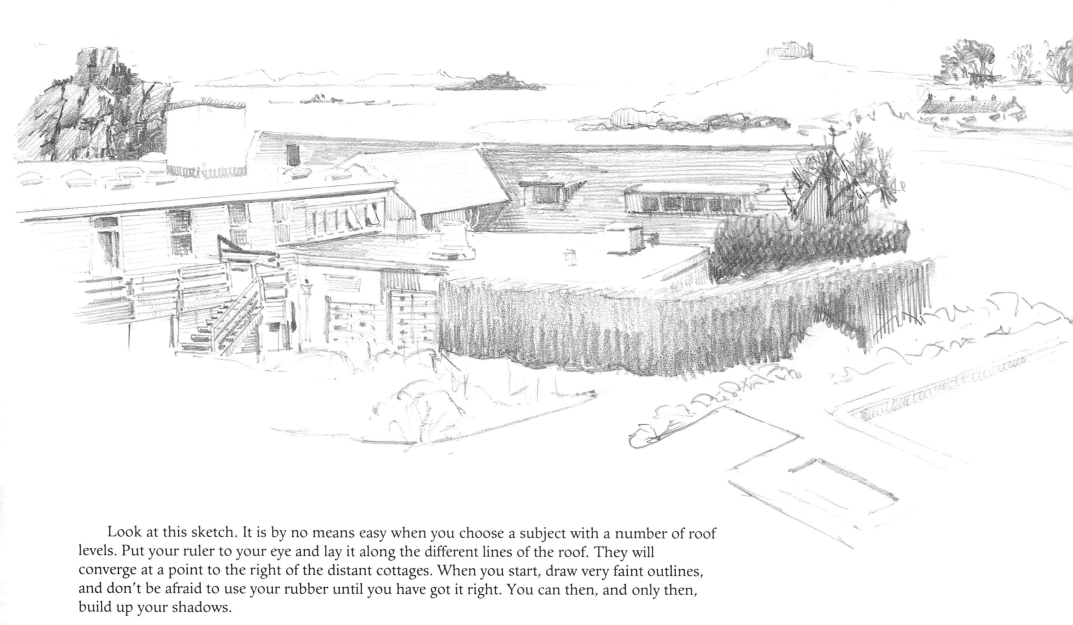

Look at this sketch. It is by no means easy when you choose a subject with a number of roof levels. Put your ruler to your eye and lay it along the different lines of the roof. They will converge at a point to the right of the distant cottages. When you start, draw very faint outlines, and don't be afraid to use your rubber until you have got it right. You can then, and only then, build up your shadows.

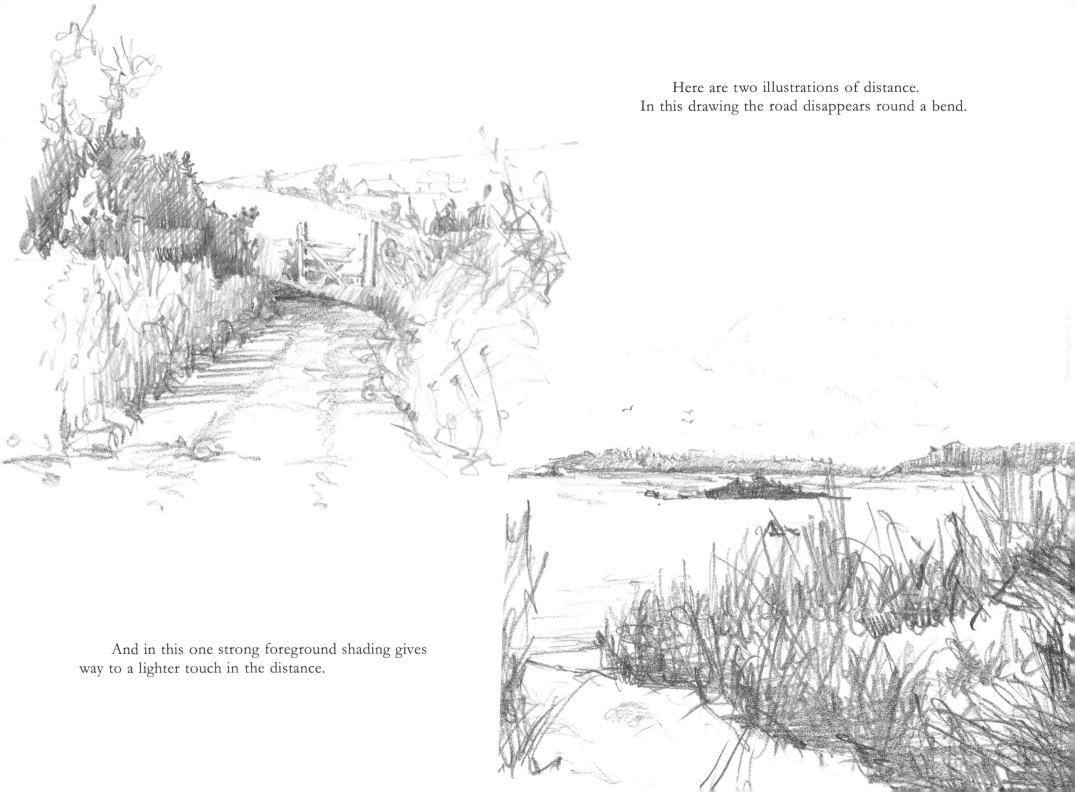

Here are two illustrations of distance.
In this drawing the road disappears round a bend.

And in this one strong foreground shading gives
way to a lighter touch in the distance.

## Trees

Trees are wonderful subjects for sketching and, having grasped one or two basic ideas, are not too difficult. Light and shade are the whole basis of drawing trees. Unless your eye dwells on a particular tree or clump you will not register much detail, whereas a further glance will take in the branches and finally every twig. This can all be achieved in your drawing. Some people will want to draw with a fine outline and the result will be totally satisfying, while others will seek to use all the pencils in the range. Some will want to put in every detail and some will achieve their results with shading alone. Sunlight and shadow are all important in producing the effect you want. Here are some examples.

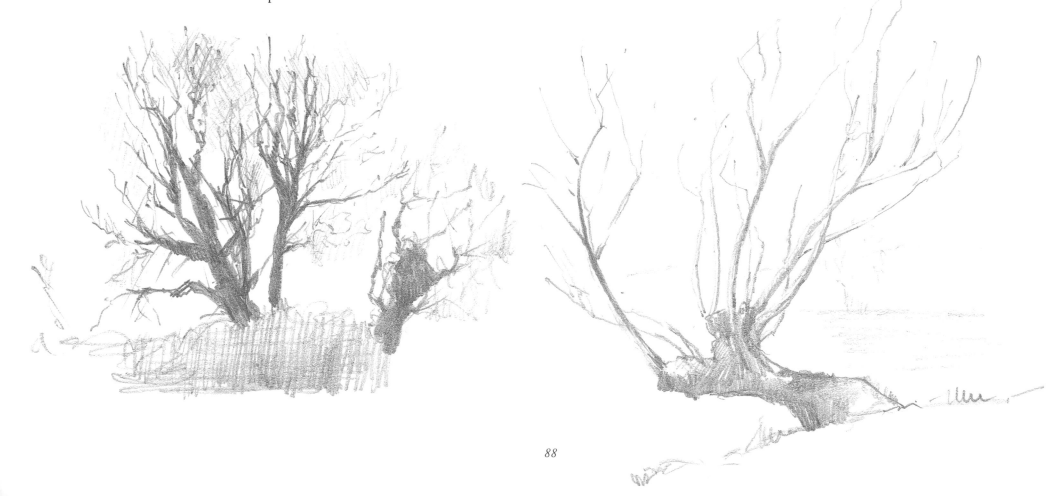

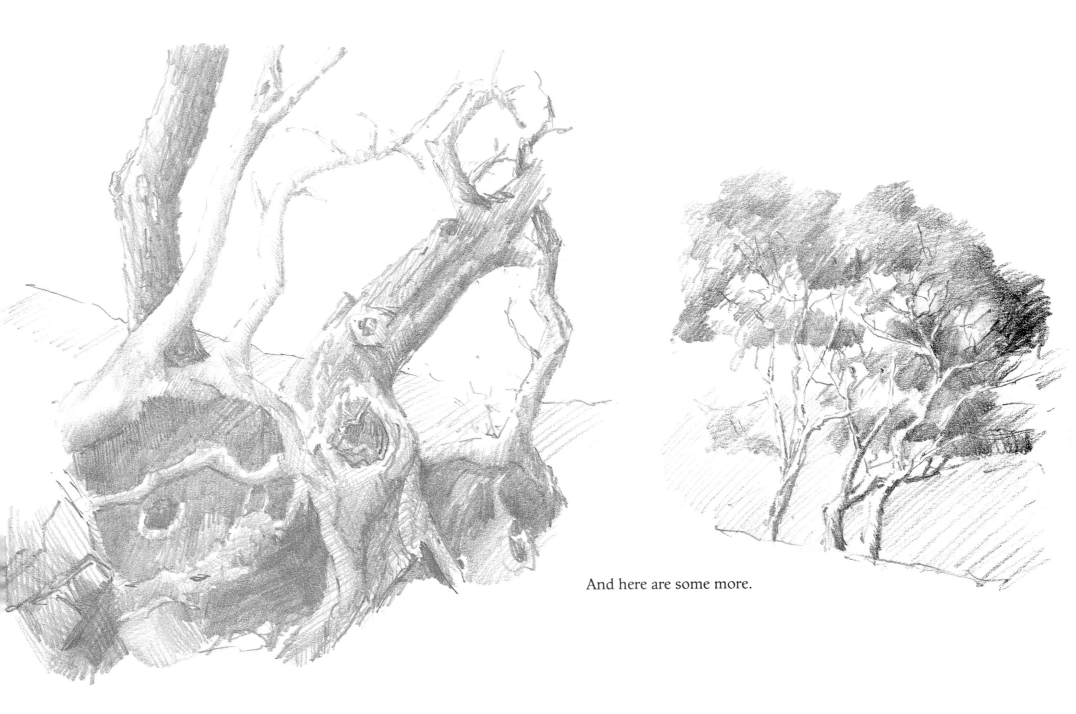

And here are some more.

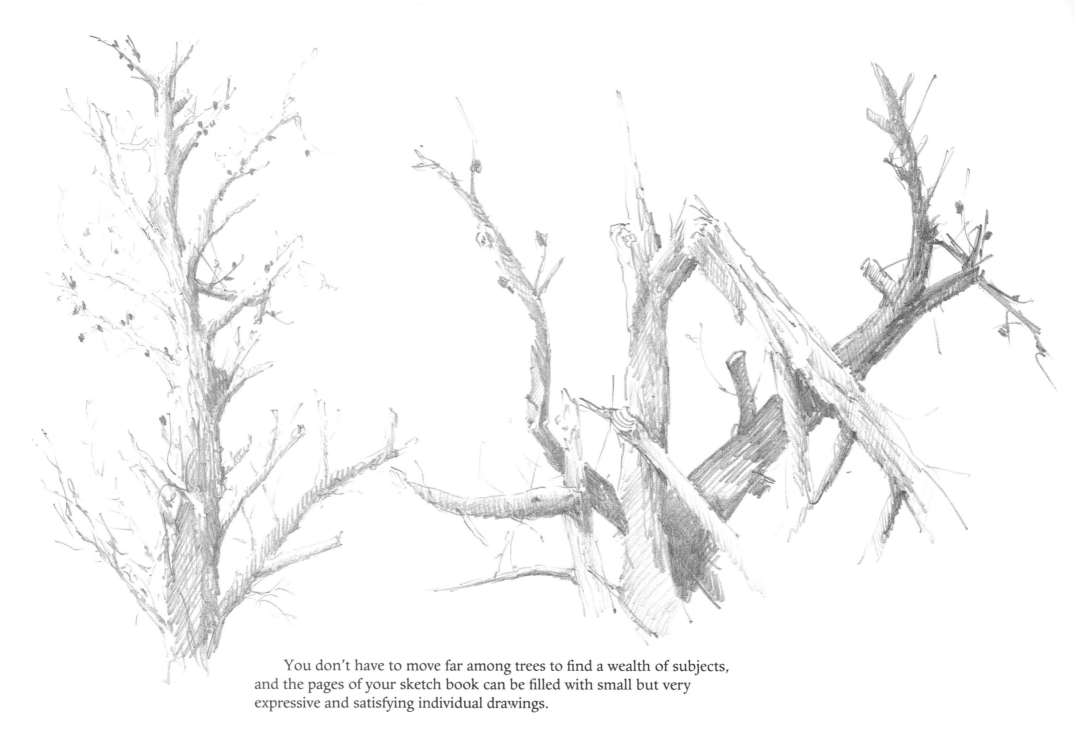

You don't have to move far among trees to find a wealth of subjects, and the pages of your sketch book can be filled with small but very expressive and satisfying individual drawings.

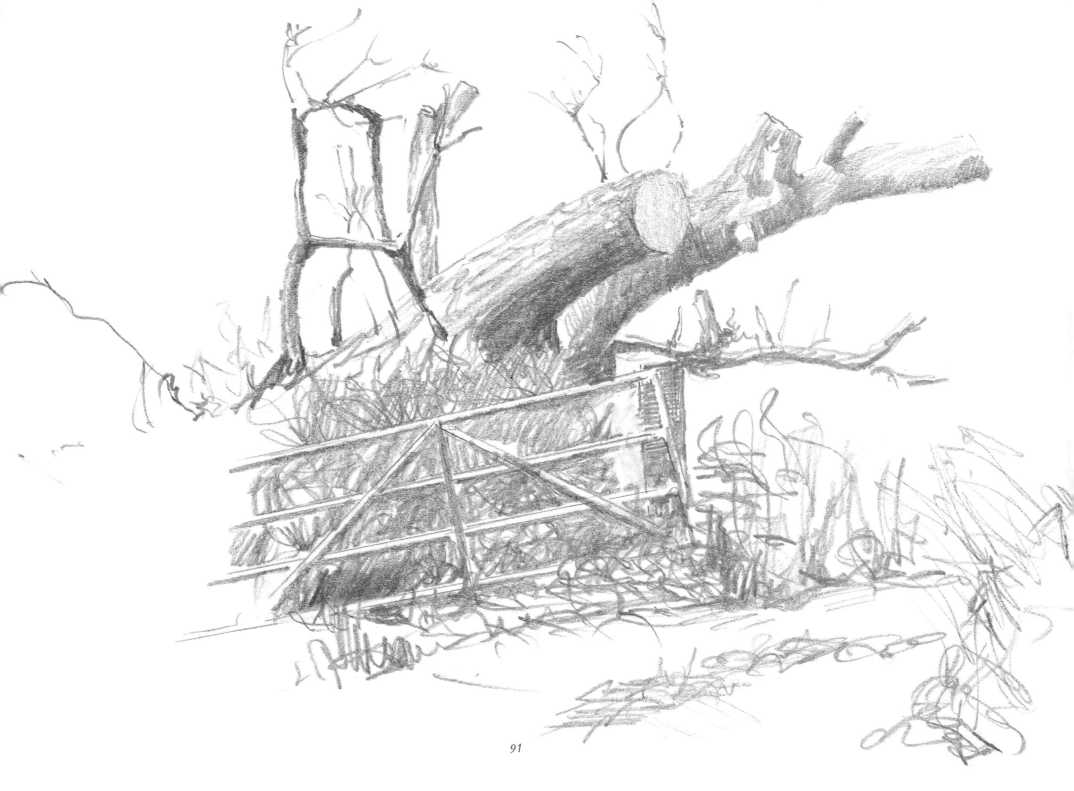

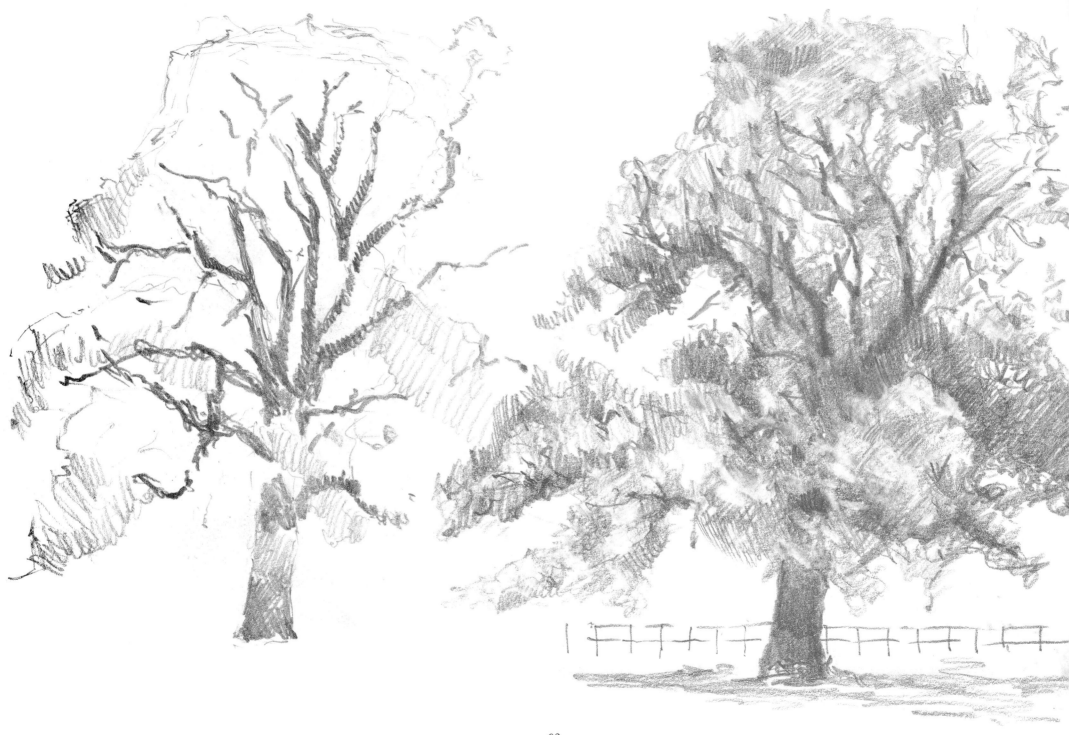

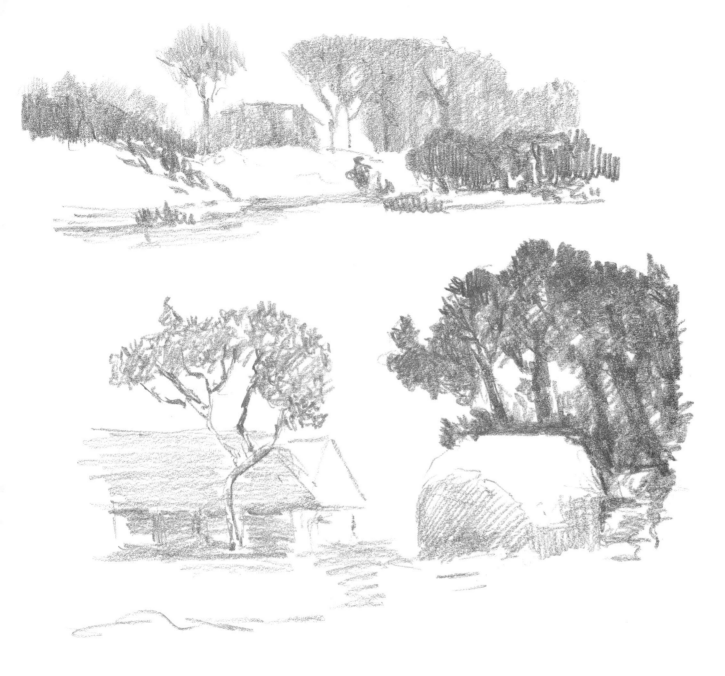

Here are two more suggestions.

The trees in the distance are no more than a block of shading with no detail, with the darker trees in front there is a feeling of distance. Half close your eyes and see that distant detail is unnecessary.

Here we have various methods of shading. Try using different pencils and shade at different angles. Think about light and shade.

The mighty oak opposite comes from a park. I sketched in the skeleton of the tree first and tried to visualise it in mid winter without its leaves. For the shading I used two pencils 2B and 4B. If when sketching you half close your eyes for a moment, you will only see massed as opposed to individual leaves and this will help to avoid too much detail.

Finally I used my rubber where I wanted highlights, but with very short strokes. I cleaned it after every stroke.

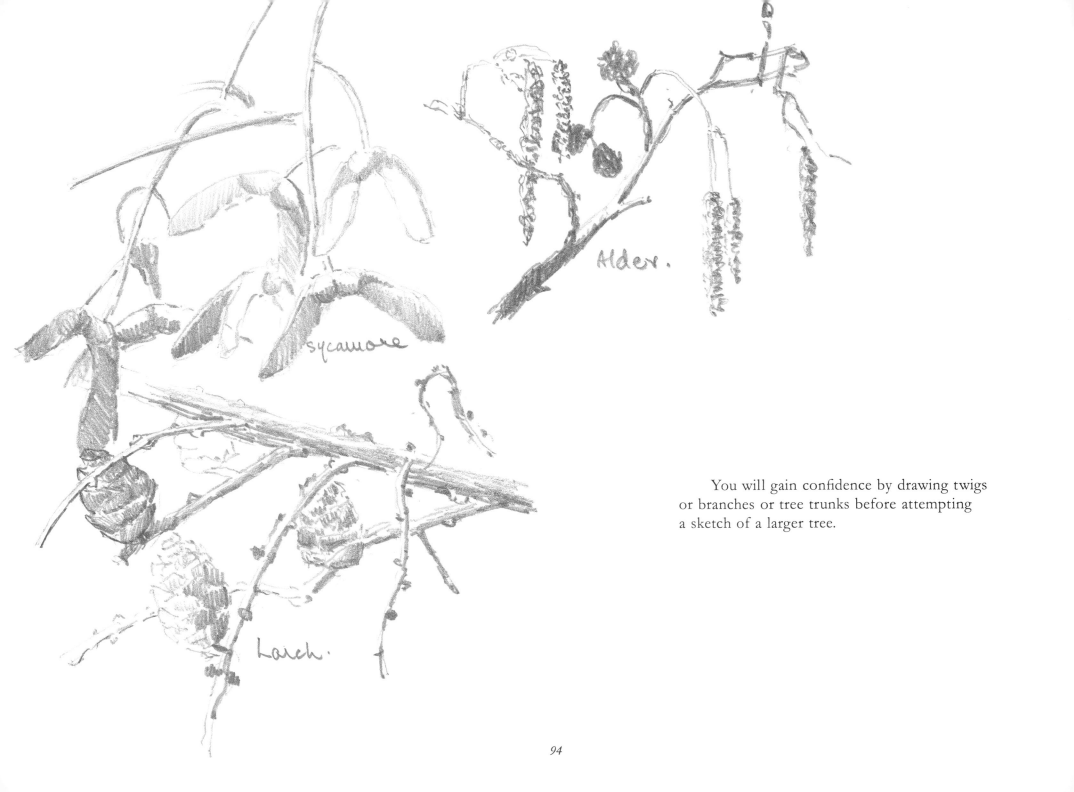

Alder.

Sycamore

Larch.

You will gain confidence by drawing twigs or branches or tree trunks before attempting a sketch of a larger tree.

Here are some further examples of trees and branches.

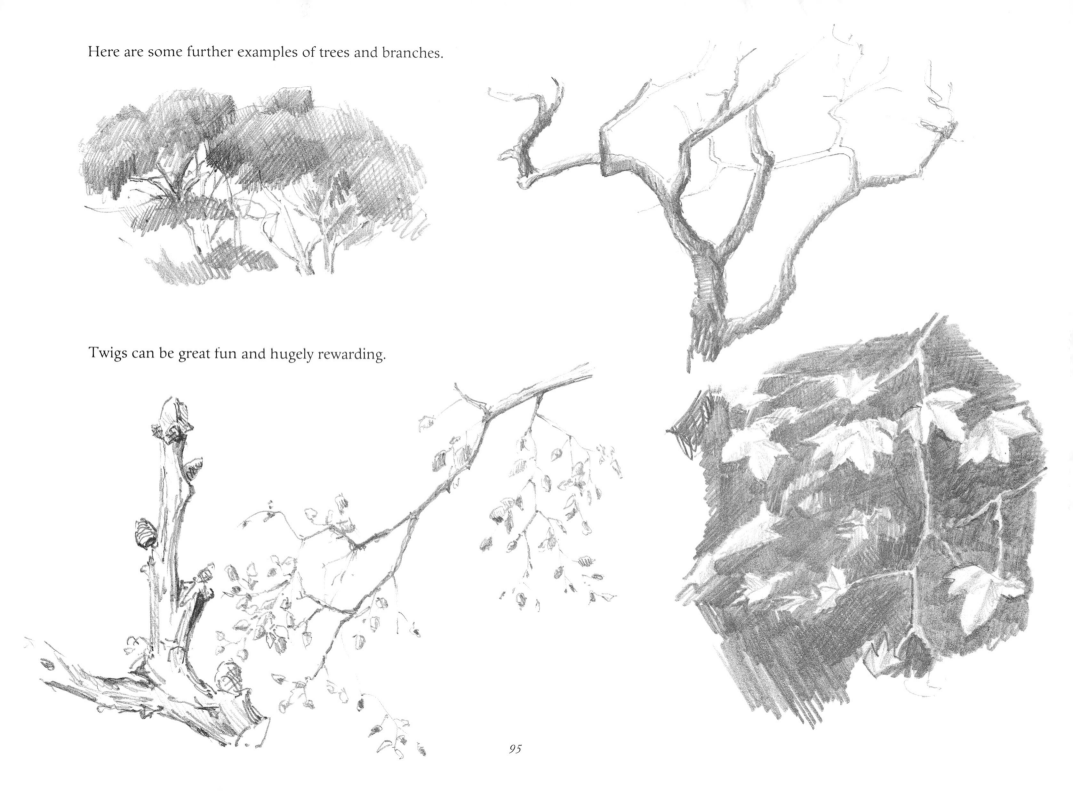

Twigs can be great fun and hugely rewarding.

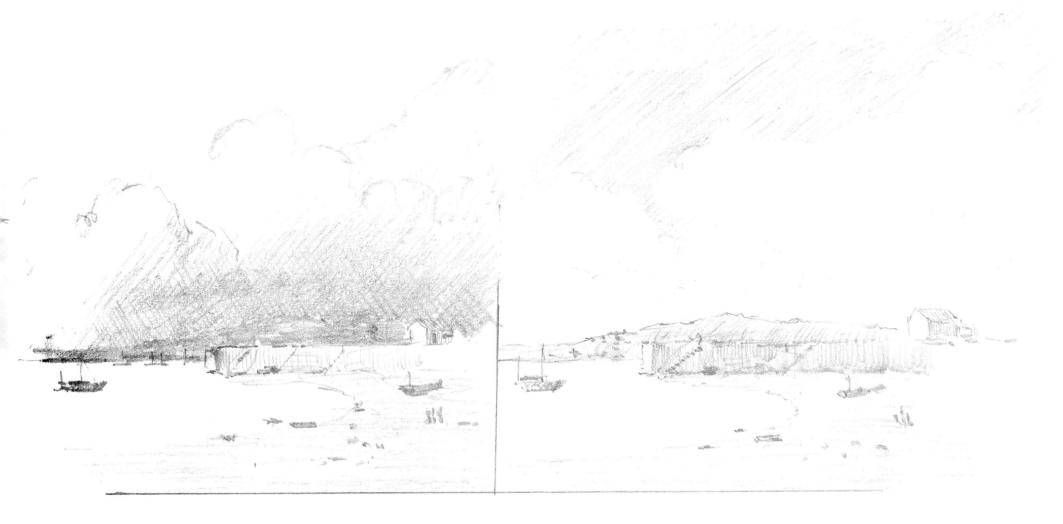

A few brief words about clouds and the sky. Clouds are fascinating but they can so easily dominate the drawing even if they are not meant to. They can always be built up, so treat them very lightly until you have sensed the correct balance for the picture. Look at the two sketches above. The sketch on the left is rather overbalanced by the strength of the sky.

The one on the right is better I think. However in the sketch on the opposite page the clouds are the dominant feature and the branches of the tree are being blown by the wind. A 6B pencil was used and the whole of the sky shaded in diagonal lines. A touch here and there with my rubber formed the softness of the clouds, then heavier shading strengthened the drawing.

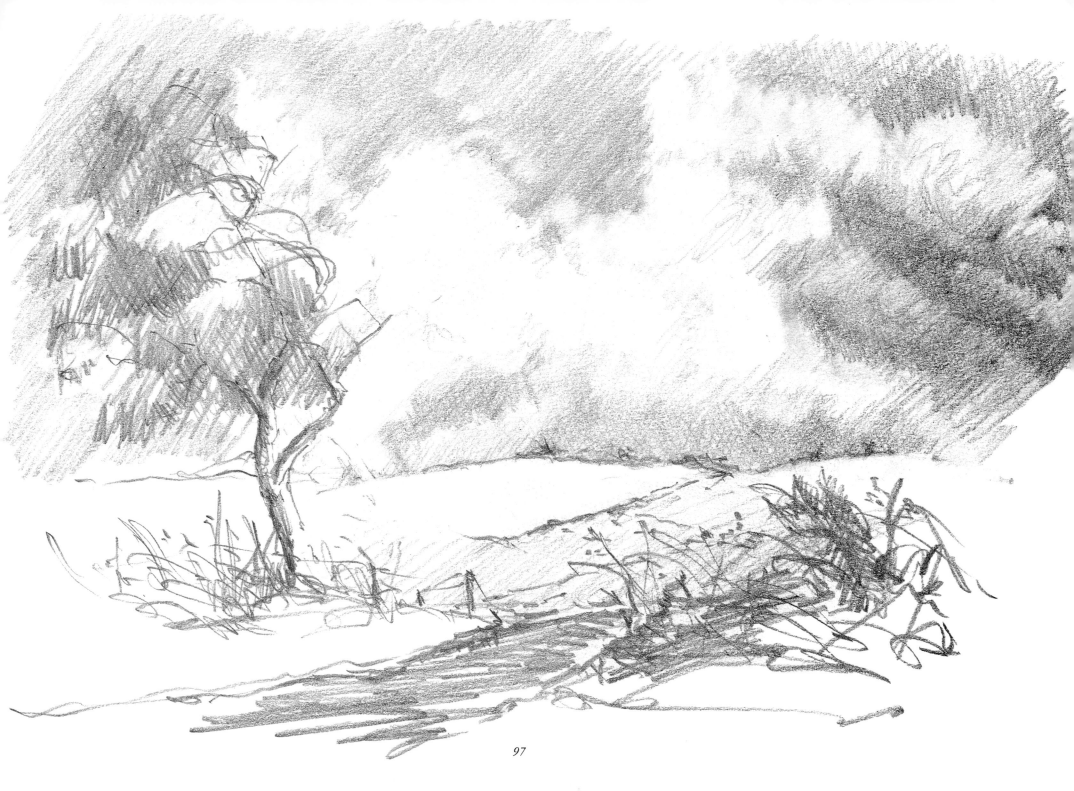

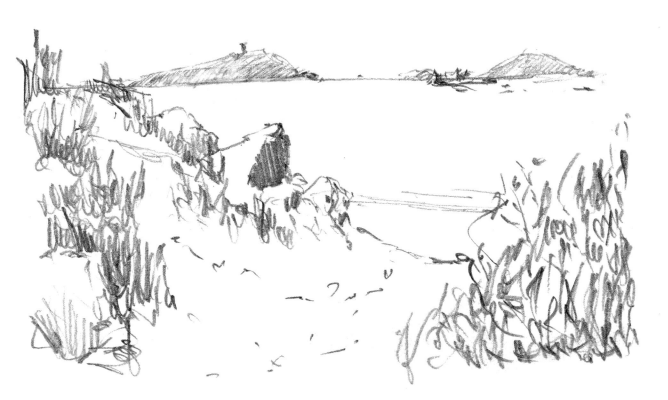

We should spend a little more time on composition. It will make all the difference to your drawing.

Spend a little time walking about to find the best spot where the balance between foreground and distance is right.

Very often there is a key object in the foreground or middle distance and if you put it in the centre of the drawing you may have problems.

Remember that the viewer's eye wants to be taken into the picture and not out of it. For instance, if you include a flock of gulls, I suggest that they are flying into the picture and not flying out of the right hand side.

Sketching from the beach presents endless possibilities and can give you many hours of enjoyment. Whether it is a view of the harbour or the sand dunes or rocks on the foreshore or even distant islands, the principle is the same.

Decide on your line of horizon.

Set out your vanishing points—if there are buildings.

Remember that you are going to convey a feeling of distance.

Plan your sketch with some small rectangles—decide on the best composition and how much you can fit in (put the cut-out rectangle or matchbox top to your eye).

Make a start by sketching in very lightly the main features, and then strengthen them with some shading. Try to keep the drawing balanced, and get a feeling of distance by outlining features in the horizon very lightly.

I am sure you are going to enjoy yourself, but keep it simple and ensure that your pencils are sharp.

Here is a simple sketch done at low water.

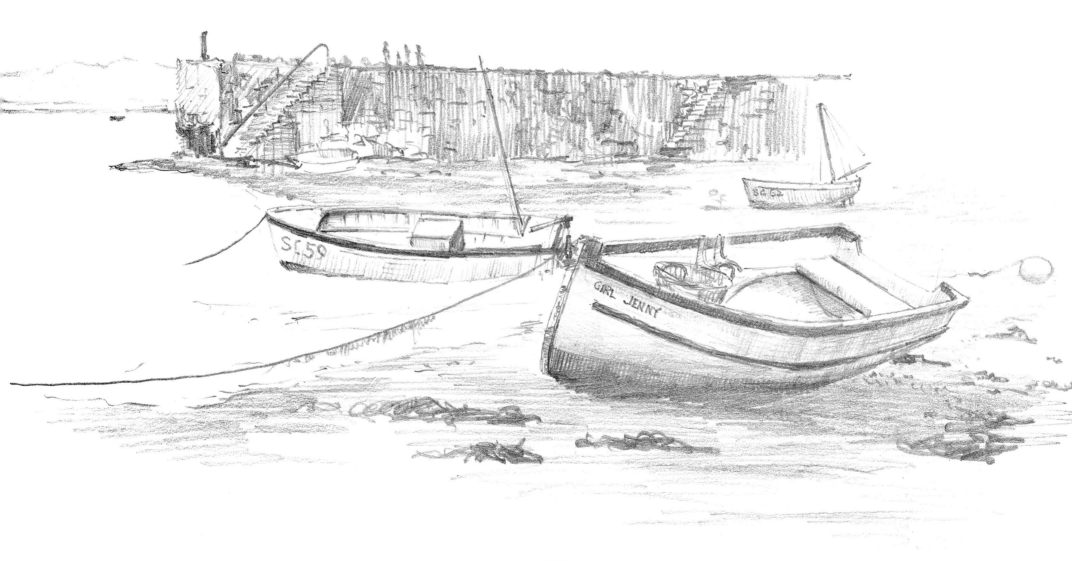

Try to have some of your pages filled with details. It is not only good practice, but it is a delightful reminder of a happy afternoon's sketching. Notice the shading in these sketches. I used a 2B pencil very lightly to draw in the outline and then a 4B.

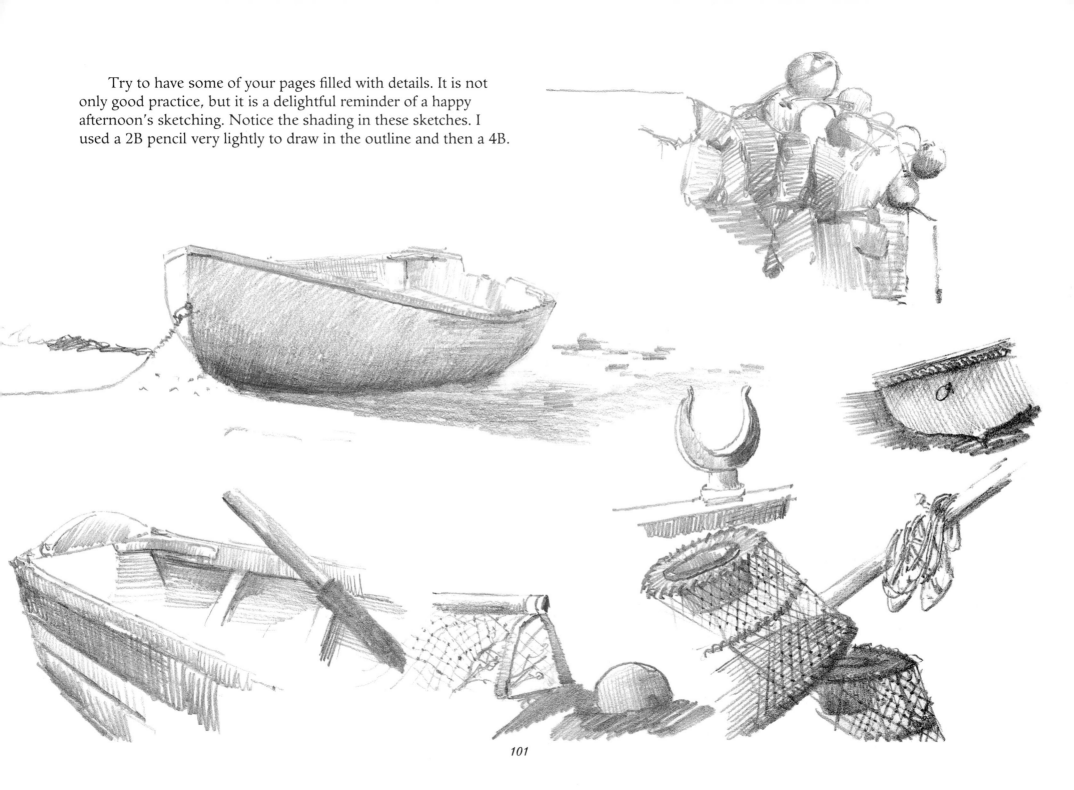

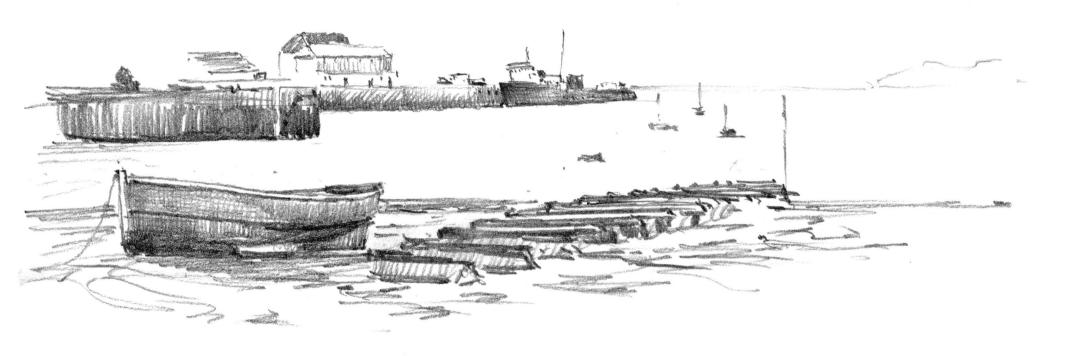

You will find that in general you are sketching a calm sea. Think before you put in too much shading. It may help to accentuate the sea, but again in many cases it will cause you problems. As a start I suggest you leave the viewer to recognise the sea, and avoid heavy shading.

Try to avoid tackling too much in your drawing. These two pages are simple, but it will help you to gain confidence if you realise that lightness can be conveyed by leaving out much of the finer detail.

I wanted to sketch from where I was sitting, but it wasn't a good composition. There is no obvious focal point which draws your eye (despite an attempt to use birds). I moved a few yards down the beach and the next sketch is more balanced.

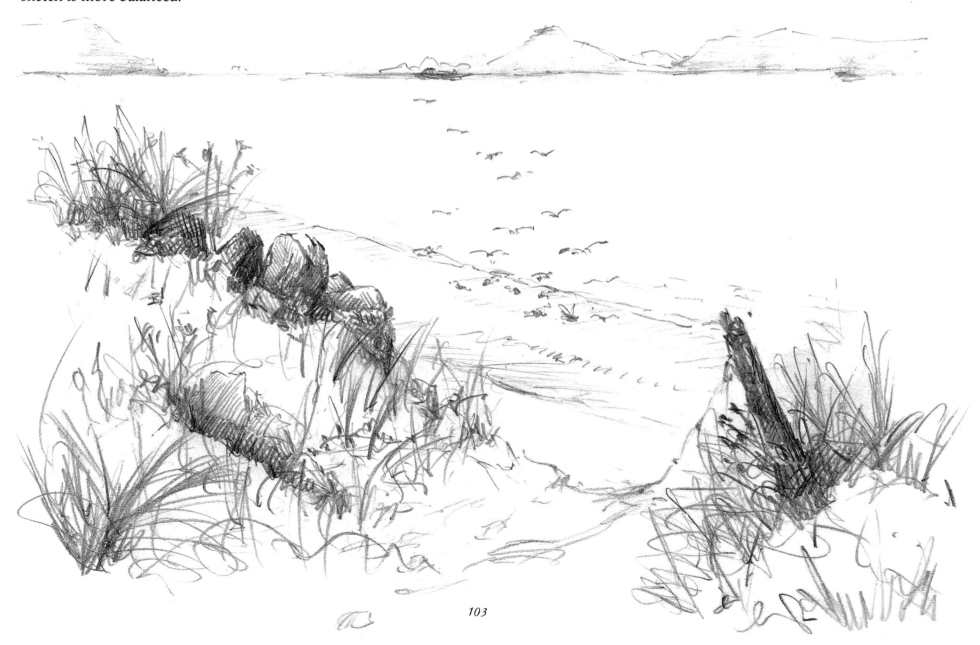

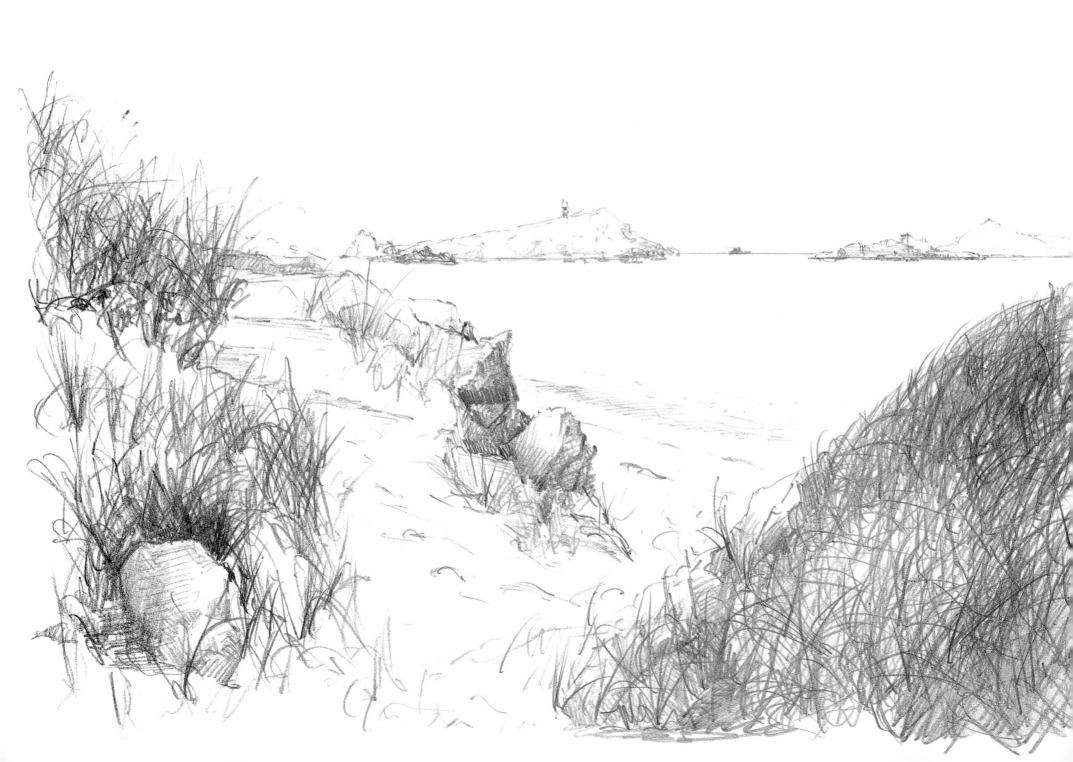

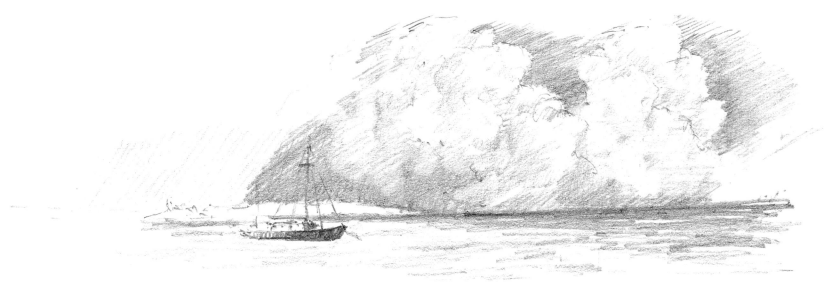

The heavily shaded boat in this quick sketch helps to give a feeling of distance.

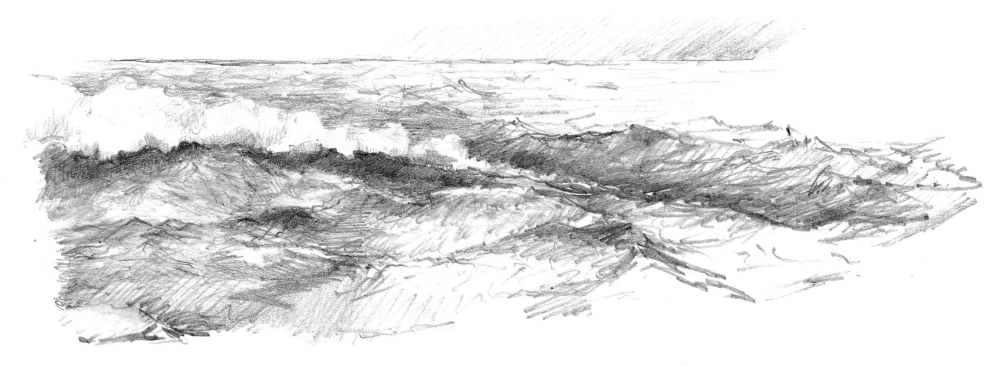

The direction of the pencil work in this drawing helps to give a feeling of movement.

A page of shading—practise the strokes as I have, starting with a light pressure, gradually increasing until the effect is a dark shadow, and then gradually ease off until at the end there is hardly any mark.

4B   2B   6B.

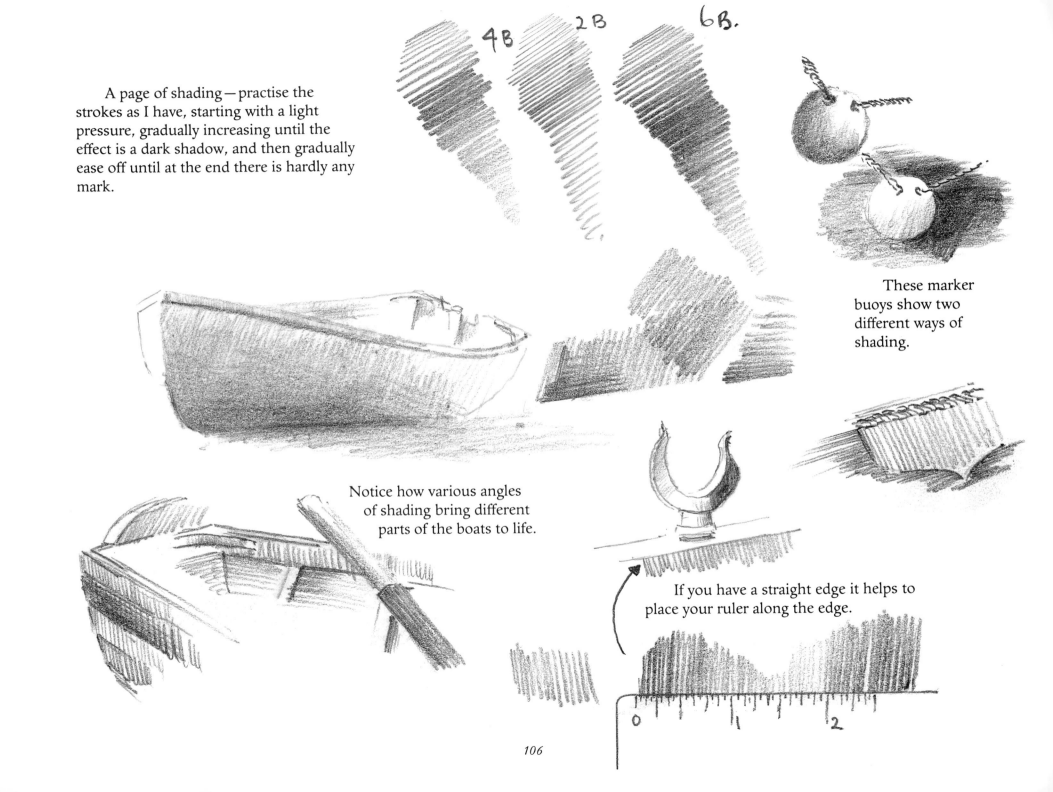

These marker buoys show two different ways of shading.

Notice how various angles of shading bring different parts of the boats to life.

If you have a straight edge it helps to place your ruler along the edge.

0   1   2

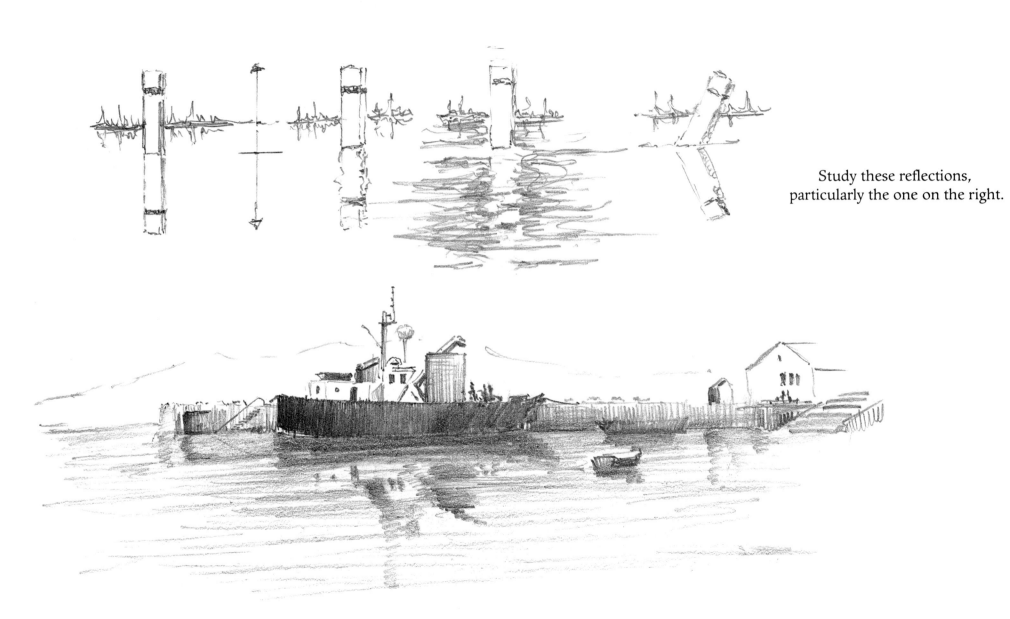

Study these reflections,
particularly the one on the right.

On the opposite page I have made a quick series of sketches to explain reflection. The top left hand sketch of posts in still water shows, in the left hand post, that the reflection is the same height as the post. The next post is in ruffled water but the outline is still there. The stick, on the other hand, is at an angle and the reflection is directly below the stick. Turn the page upside down and look at the mirror image.

The barges tied up on the opposite bank are in completely still water and the reflection is an exact replica, while the beached barge is on sand with puddles which give an intermittent reflection in the water. The reflection breaks off where the sand is present.

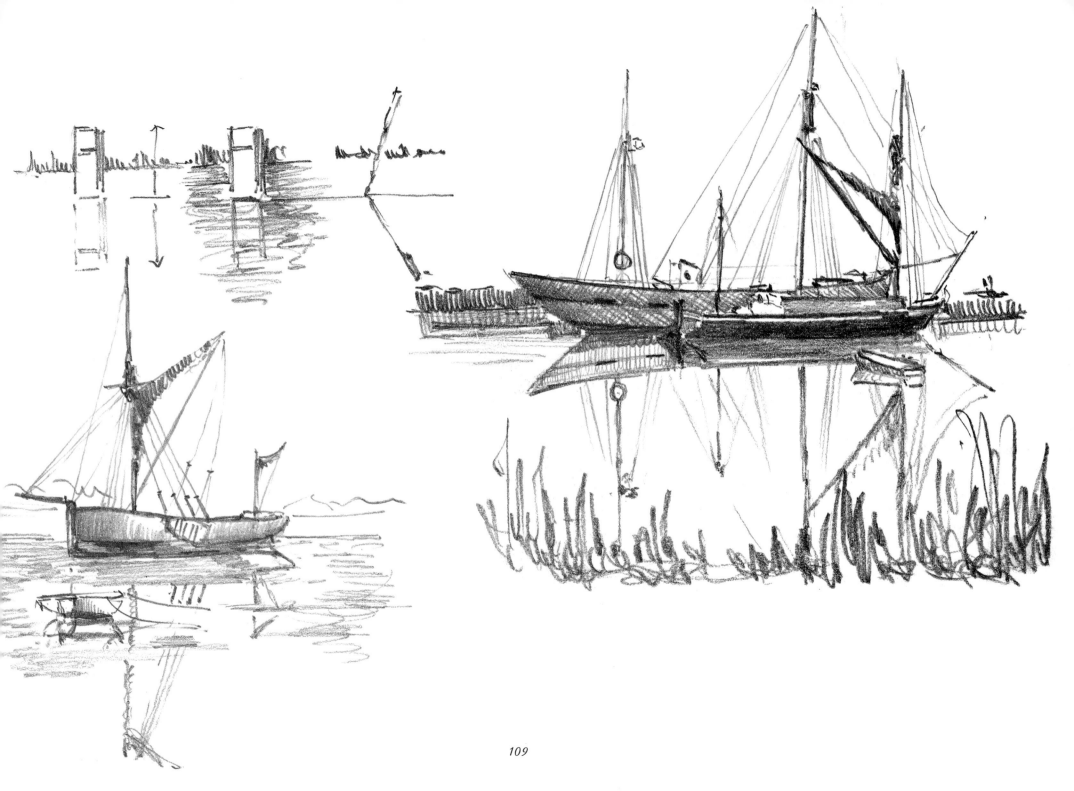

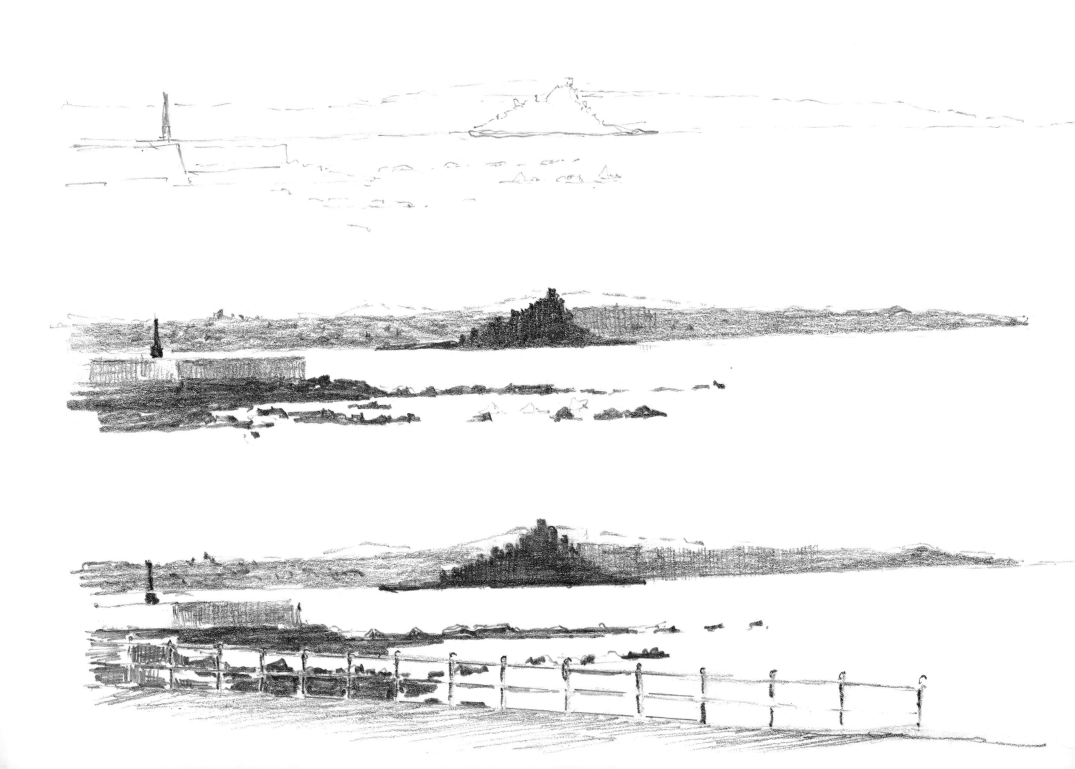

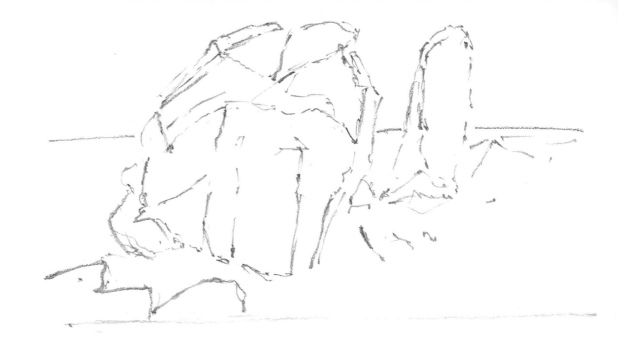

On the opposite page is St Michael's Mount. I suggested to you that it is probably better to place any dominating feature in the foreground or middle distance away from the centre. In this drawing I've done the opposite which only goes to show that there are exceptions at times. Of course in this case the Mount is in the distance and is the subject of the painting. Try placing a book to the left or right of the sketch to block off a part to see if the composition could be improved. It seems to me to be about right.

Rocks present problems and sometimes it isn't easy to produce that feeling of sheer bulk and roundness. One way is to vary your shading from leaving the paper blank to using a 4 or 6B pencil.

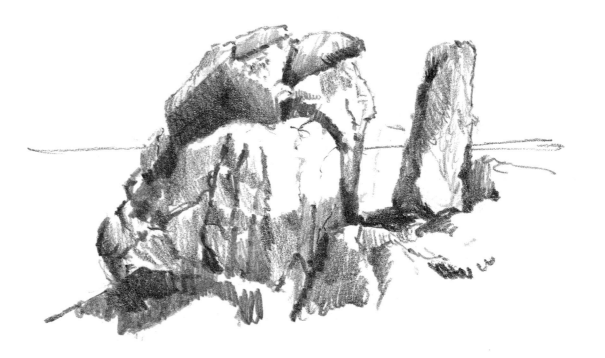

I want to keep plugging away at you about lightness of touch. Everyone has their own method of working, but whereas with watercolours and oil paints the colour can tell the story, here the pencil has to do it all.

These boats tied up to the quay were not easy and the very faint outline drawing had to be corrected quite a lot before I began shading. The problem is when to stop. I began by building up the reflections but have left it as it is. The water and sky are now a part of your imagination. You may wish to have a completely different treatment which is perfectly valid, but it is wise to start with a light touch.

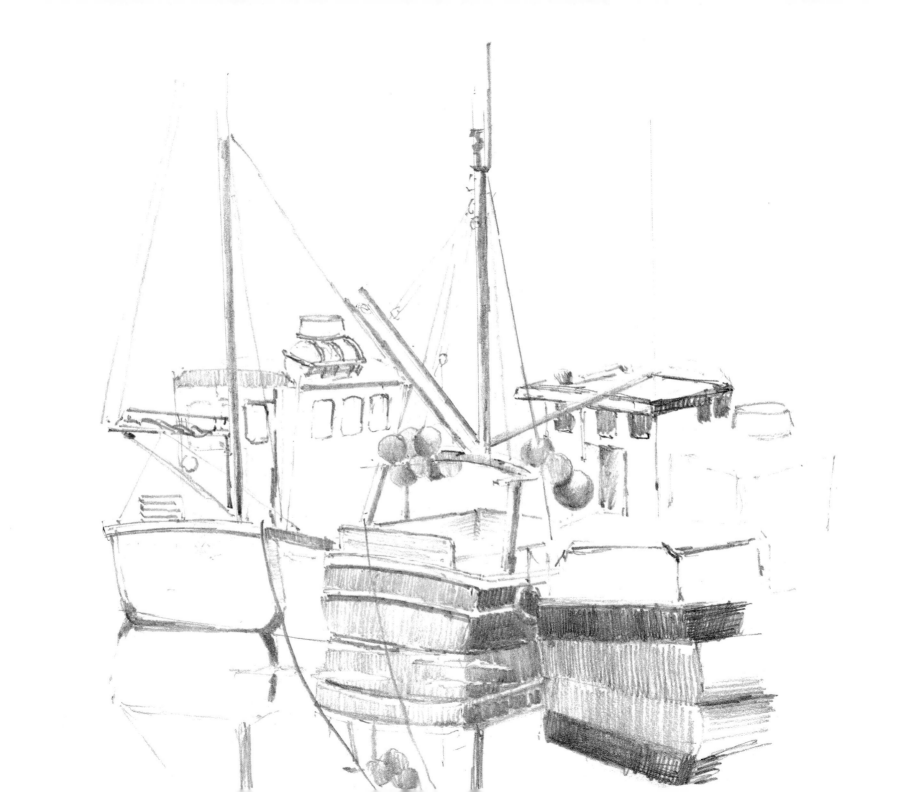

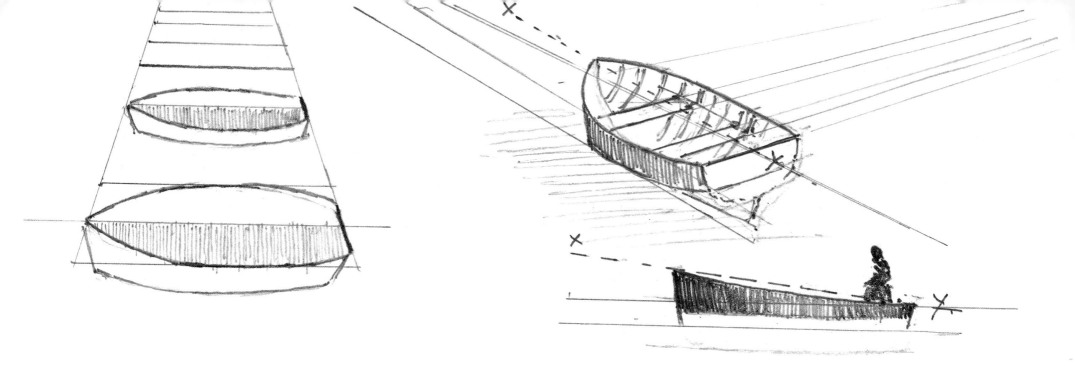

Small boats are attractive subjects, so it is important to understand the principles of perspective. It is not difficult, as we know lines move to one or more vanishing points at eye level.

In the left hand drawing one boat is further away than the other, as you can see. What may not be quite so obvious is that the nearer shaded half of each boat is slightly larger than the other half. This is because the unshaded half is further away.

In the right hand drawing there are two vanishing points. Because the boat is lower in the water and the flare of the bow is pronounced, the bow is higher than the stern, as shown on the lines XY.

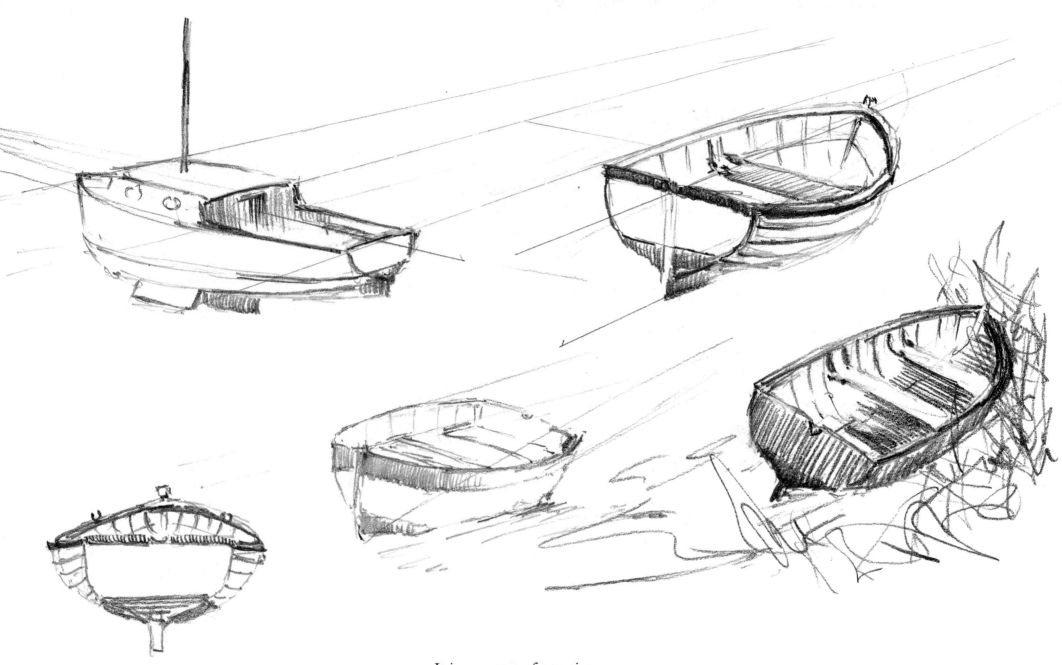

It is a matter of practice.

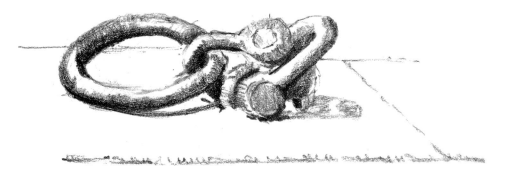

In the beginning there is a great opportunity 'above the tide line' either on holiday or if you live near the sea.

The golden rule must be to select subjects within your present field of understanding. These two items were on the quay at Newlyn. Look at them carefully.

I used my rubber to overcome problems of accuracy and didn't bother with the rest of the quay or the trawlers alongside. It was just a study in shading and started with a barely visible outline with an HB pencil. When I had got it right I used a 2B to build up the shading. Notice from where the light was coming.

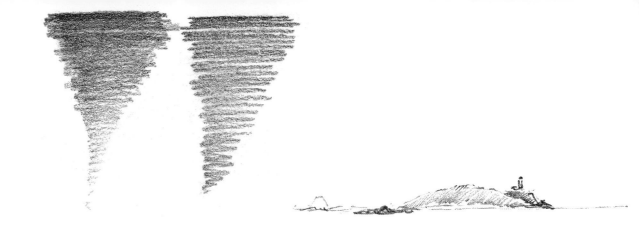

Here are some ideas which you can tackle.
The simplest subjects when filling a page of your
sketch book will give a lot of pleasure.

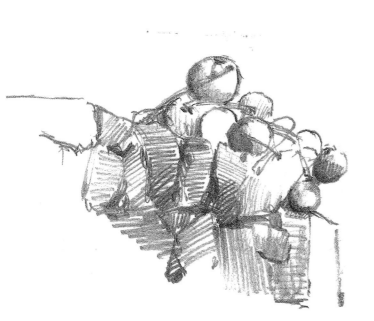

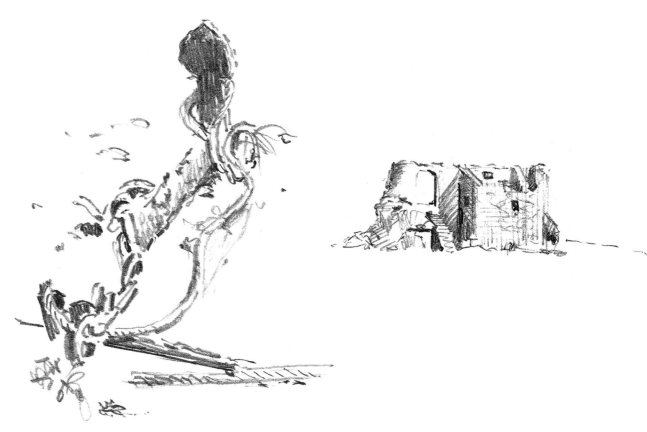

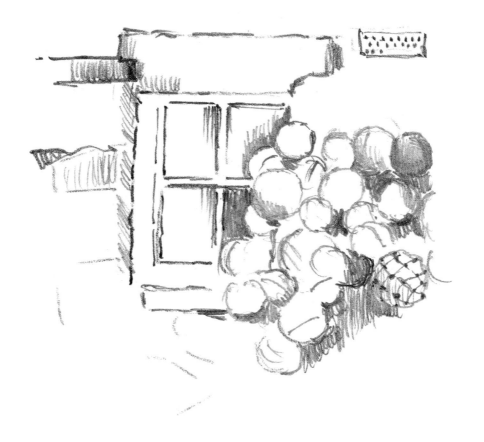

When I was drawing this faint outline I used my rubber to correct mistakes, and my shading picked up darker areas all over the drawing. It is not a question of finishing the top left corner and working down—it is better to build up the shading in all parts of the sketch before we imagine depth and the third dimension. Be careful not to overdo the shading or you may be left with no highlights. Finally, I used my rubber to put a reflective shine on some of the lobster pot floats.

I was first attracted to the window by the colour—the floats were white, yellow, red and orange and made a wonderful subject for a painting against the granite wall.

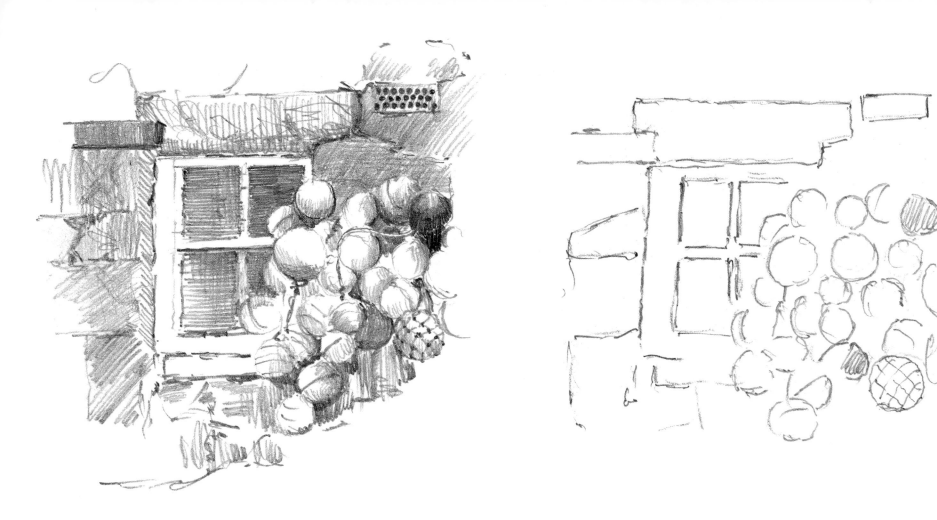

This may seem to have been difficult. It isn't really.
I sat on a wall and **very** lightly drew in the window and the
surrounding stonework, just the outline.

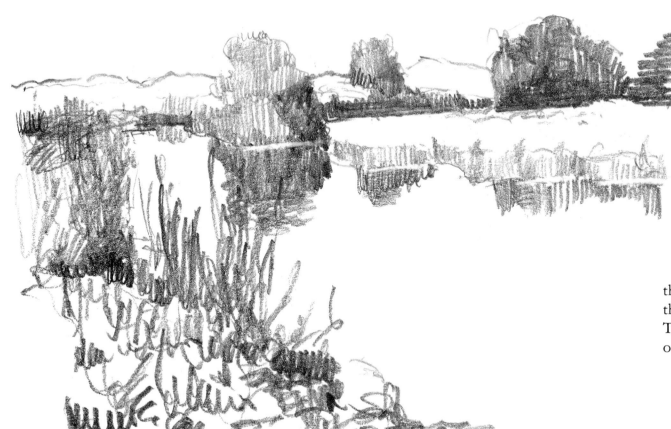

Inland rivers are normally calm and provide the most marvellous subject for sketching. Here the river Avon in Hampshire is a perfect example. This little drawing, which did not take long, has one or two points worth noting:—

The sky is left blank.

The river is left blank.

The distant hills are in outline only.

The trees are strongly reflected in the water.

I used the edge of my rubber to touch the paper in order to show the edge of the water at the bottom of the river bank.

The foreground is quite strong and dark and forms a natural edge to the bottom of the sketch.

The bottom right hand side is left completely blank.

In this way your imagination fills in the gaps and the composition provides a feeling of distance and serenity.

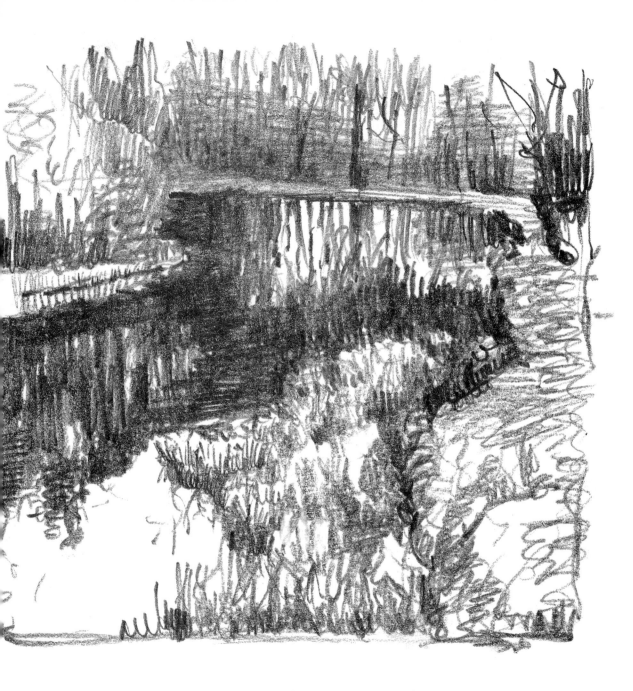

Here is quite a different treatment. There is a feeling of still water but it is deeply shaded with reflections from surrounding trees.

From the pencil strokes you will see that I worked fast with 2B and 4B pencils and there is an abrupt change from dark to completely white paper.

In reality there were primroses covering the grass on the edge of the river, and the reeds had died back during the winter. Go for simplicity and again, it is worth half closing your eyes to blur every little detail.

## Sketching in Towns and Cities

Perhaps you live in a town and don't have the chance easily to sketch in the countryside. There is a wealth of interest and you can have great fun — provided you approach your work as we have done throughout the book. Start by looking at buildings or compositions as subjects for sketching. You may not want to sit on a stool in the High Street, so find a seat and look all round. Perhaps you are sitting in your car, which is an admirable place to remain incognito while you sketch. Don't feel that you must sketch the whole of a scene — it's not necessary.

Look out of the window at home and see if there is a chimney pot in view. They are simple, don't take long and give you practice in shading and proportions — so don't despise the chimney pot.

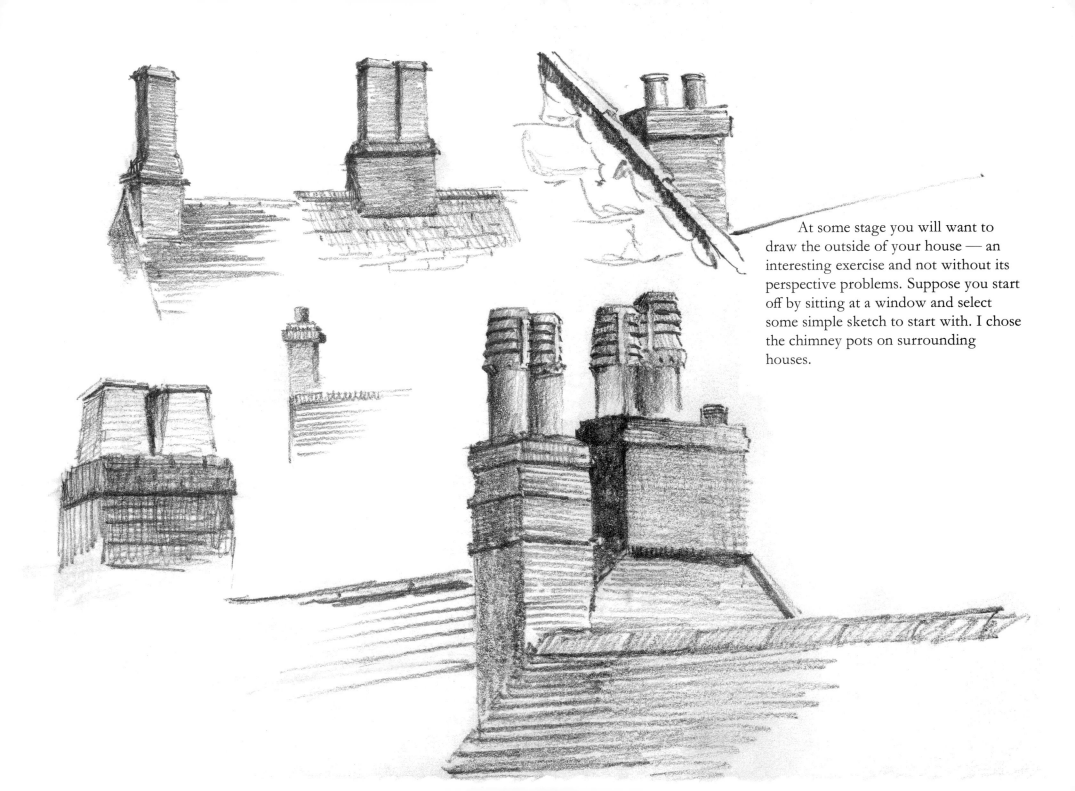

At some stage you will want to draw the outside of your house — an interesting exercise and not without its perspective problems. Suppose you start off by sitting at a window and select some simple sketch to start with. I chose the chimney pots on surrounding houses.

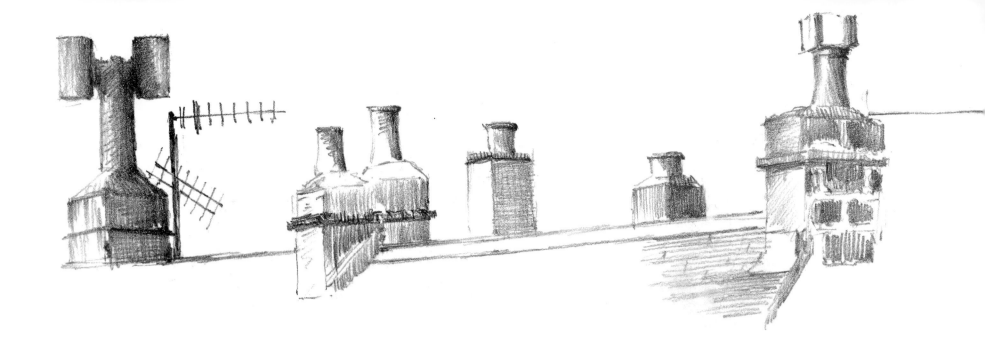

Rooftops and chimney pots never fail to capture my interest. There's a whole landscape up there above the houses, bursting with fascinating shapes, angles, textures, light and shade, all of it wonderful material for your sketch book. And just think how few people ever bother to look! Good drawing is as much about observation, learning to look and see, as it is about practice. The two go together well.

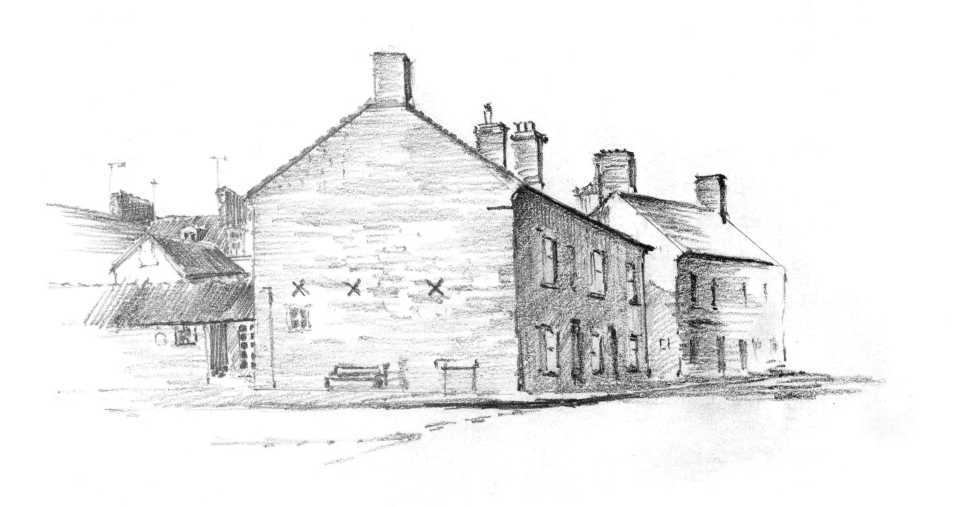

Practise drawing your house from different angles, leaving the adjoining buildings to fade out.

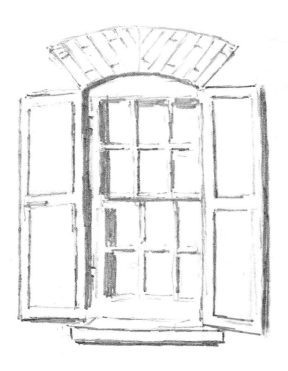

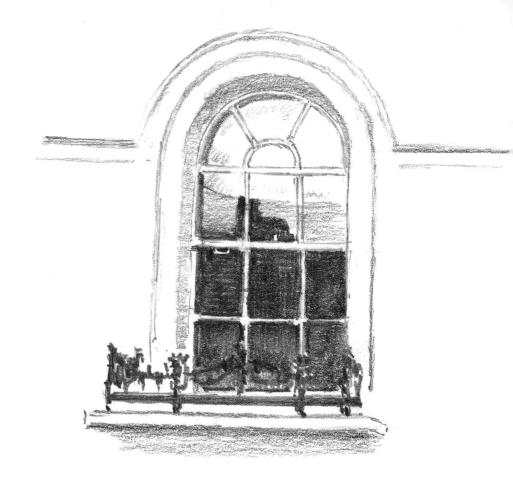

Windows and doorways often have interesting architectural details and make lively studies for your sketch book. Keep an eye open for the unusual, and make a habit of sketching it when you find it. Remember to use your sketch books as a resource for your more ambitious drawings—borrow details and ideas whenever a new composition demands it. Among the details on these two pages, note how panes of glass, above right, come to life when they reflect the light outside.

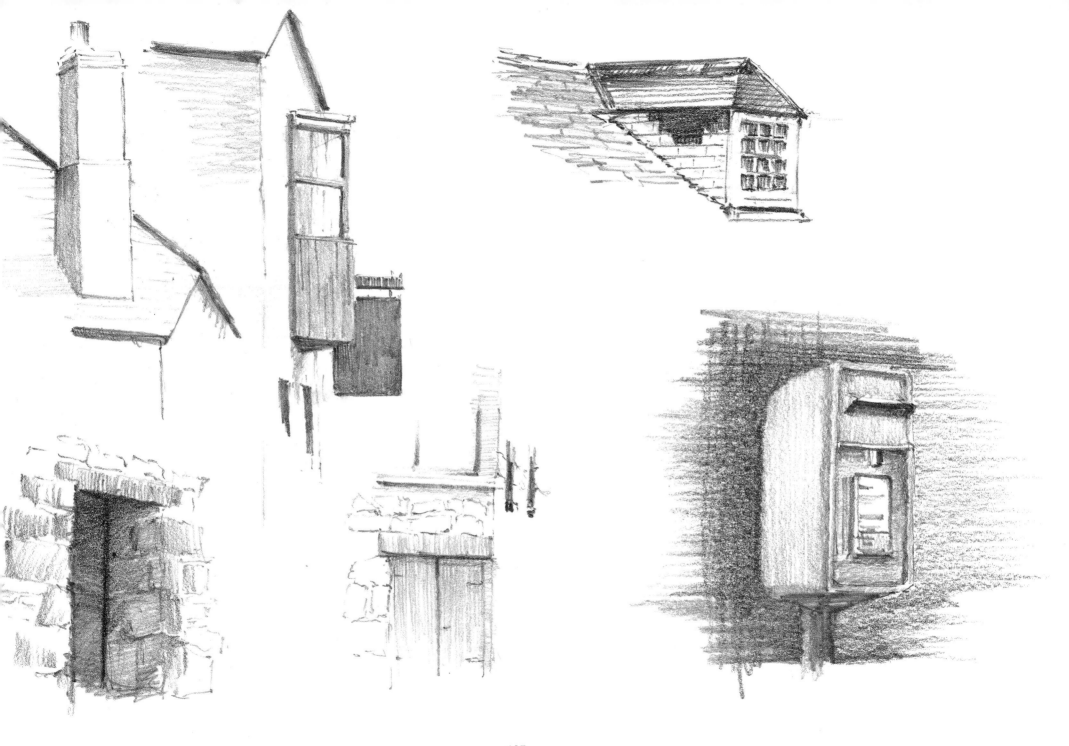

## *End Note*

There is no single and correct approach to drawing — and certainly a pencil is not the only medium available. All of us are attracted to a particular style and if you feel happier with a stick of charcoal or a drawing pen, that's fine, use them.

I am convinced that more people give up drawing because they attempt a subject that is beyond them than for any other reason. That is why I have suggested you make a start with simple sketches of everyday objects around the house. Take it as a matter of course that with only a little time to spare you will soon be able to produce pleasing sketches. You will find it relaxing and enjoyable, just as I do, and a good way to build up your confidence.